The Oil Painter's Bible

The Oil Painter's Bible

An essential reference for the practising artist

Marylin Scott

A QUARTO BOOK

Copyright © 2005 Quarto Publishing plc
This edition published in 2016 by
Search Press Ltd
Wellwood
North Farm Rd
Tunbridge Wells
Kent TN2 3DR

Reprinted 2017 (Twice)

All rights reserved. No part of this publication may be reproduced, stored in a retrieval system, or transmitted in any form or by any means, electronic, mechanical, photocopying, recording or otherwise, without the permission of the copyright holder.

ISBN: 978-1-78221-392-5 QUAR.OPB

Conceived, designed and produced by Quarto Publishing plc The Old Brewery 6 Blundell Street London N7 9BH

Project Editor: Mary Groom
Art Editor: Tania Field
Designer: Penny Dawes
Assistant Art Director: Penny Cobb
Picture Researcher: Claudia Tate
Photographer: Martin Norris
Indexer: Pamela Ellis

Art Director: Moira Clinch Publisher: Paul Carslake

Manufactured by Modern Age Repro House Ltd, Hong Kong. Printed by Toppan Leefung Printing Ltd, China.

Parts of this book have previously been published in The Encyclopaedia of Oil Painting Techniques, 100 Great Oil Painting Tips and The Oil Painter's Pocket Palette.

Contents

Introduction 6

Materials 8

Paint choices 10
Brushes 12
Palette and painting knives 14
Painting surfaces 16
Fabric supports for oil painting 18
Stretching canvas 20
Painting mediums 22
Toning the ground 24

Colour 26

Understanding colour mixing 28 Opacity and strength of colour 30 Choosing a palette 32 Useful extra colours 34 Mixing greens 36 Using greens 38 Mixing browns 40 Using browns 42 Mixing oranges and purples 44 Using oranges and purples 46 Mixing greys 48 Using greys 50 Mixing skin tones **52** Using skin tones 54 Overpainting with transparent colours 56

Techniques 58

Basic techniques 60

Fat over lean 60

Alla prima 62

Blending 64

Building up 66

Underdrawing 68

Brushwork 70

Analysis: Using brushwork 72

Dry brush 74

Hard and soft edges 76

Analysis: Hard and soft edges 78

Coloured grounds 80

Wet-in-wet/Wet-on-dry 82

Corrections 84

Advanced techniques 86

Glazing 86

Impasto 88

Analysis: Impasto 90

Knife painting 92

Analysis: Knife painting **94**

Finger painting 96

Sponge painting 98

Scumbling 100

Tonking 102

Scraping back 104

Sgraffito 106

Analysis: Sgraffito 108

Texturing 110

Underpainting 112

Imprinting 114

Masking **116**

Monoprinting 118

Mixed media 120

Useful hints and tips 122

Materials 122

Colour 124

Painting surfaces 128

On location 130

Subjects 136

Landscape 138

Summer 138

Winter 140

Water **142**

Moving water 144

Skies **146**

Trees **148**

Shadows 150

Tutorial: Landscape 152

Buildings 158

Viewpoint 158

Composition 160

Urban scenes 162

Interiors 164

People 166

Achieving a likeness 166

Composing a portrait 168

The figure in context 170

Tutorial: Painting a portrait 172

Still life 176

Arranging the group 176

Found groups 178

Floral groups 180

Tutorial: White flowers 182

Index 188

Credits 192

Introduction

The Oil Painter's Bible is a must for anyone who has not used oil paints before, and even those who are familiar with the medium may find some surprises among the range of techniques – and hopefully some new inspiration in the gallery of finished pictures.

The book is divided into four main sections: Materials, Colour, Techniques and Subjects. In Materials, you will find information on

everything you need to purchase, from paints and brushes to knives, painting mediums and surfaces. You will also discover how to save money by preparing your own canvases and boards, and starting with a basic range of paints. The Colour section explains some of the

▲ Learn about tools and materials

basic properties of colours and gives hints on colour mixing and choosing a 'starter palette' – essential advice,

since manufacturers produce such a wide and bewildering range of different tubes whose names may not mean much until you have tried them out.

The Techniques section helps you to master the basic skills involved in building

► Build a basic palette

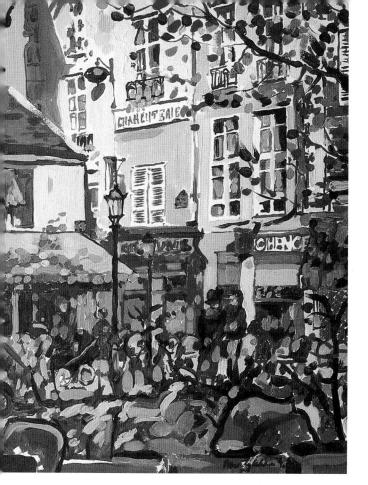

Look at paintings by established artists

find out which ones appeal to you. All the techniques are shown in a series of clear, step-by-step demonstrations done by a team of professional artists, with informative captions telling you exactly what to do to achieve the effects. In the final section, Subjects, you will see the techniques in action.

Finished paintings by a

wide range of well-known oil painters illustrate the diversity of style possible with this versatile medium, while texts and captions provide hints on topics such as composition and uses of colour to bolster your technical know-how. Looking at other artists' work is an essential part of any artist's learning curve, and you may find that the example of others helps you to establish your own style.

But the most important way to become an artist is to enjoy what you are doing, and to be willing to experiment with your own ideas and working methods, so treat the book as a springboard to launch you into the exciting world of picture making.

Discover new skills

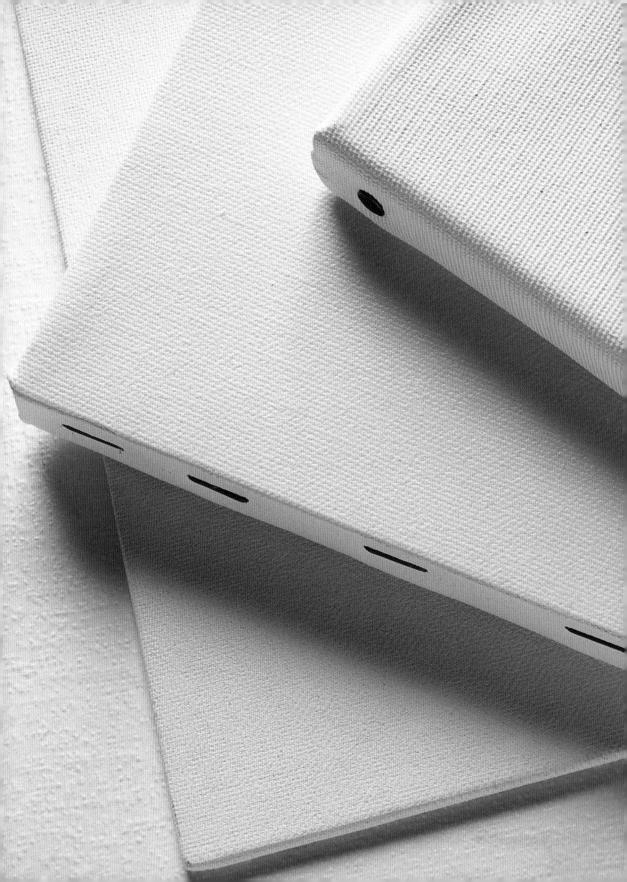

1 Materials

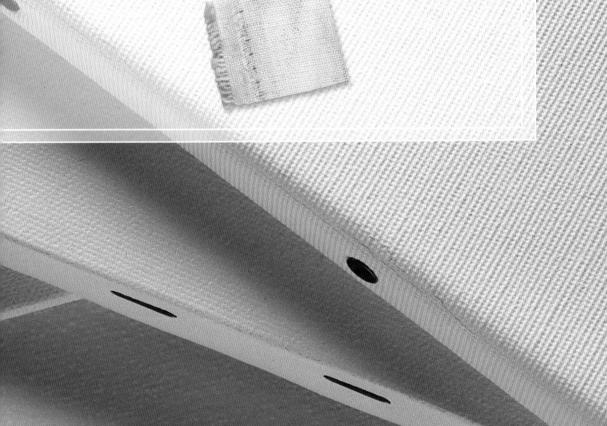

Paint choices

There are two basic types of oil paint: artists' colours and students' colours, with the latter being considerably less expensive and sold in smaller colour ranges. There is no reason why you should not begin with students' colours to get the feel of the paint, but as you become more experienced and need to expand your range of colours, you should consider moving up the scale to artists' quality, since the colours are purer and brighter. They also have more tinting power than the cheaper paints, which contain

less pigment and are bulked out with thinners, so you will end up using less of them.

It is best to avoid buying a boxed set of paints, as these often contain colours you may never use. All oil paints can be purchased individually in standard-sized tubes, so start with a small range, as suggested more as needed

Paint boxes

Wooden paint boxes like this (right) can be purchased without the paints, so that you can buy your own selection. They are made with special trays for the paints and mediums, a long slot at the front for the brushes and a palette that fits into the lid. Paint boxes like this are not essential, since some of the heavy plastic boxes made for home improvement tools make a good alternative, but the traditional boxes are a great help when working on location, because you have everything you need in one place.

Paint quantities

You will use more white than any other colour, so it is wise to buy a larger tube than the standard 38ml size. All paint manufacturers produce 115ml tubes and some also offer tinned versions of white. Smaller tubes of some colours are also made by some manufacturers, so for any very expensive colours or those you know you won't use often, buy the smaller tubes.

Large tubes of white can be bought in both artists' and students' quality. The latter are an economical choice.

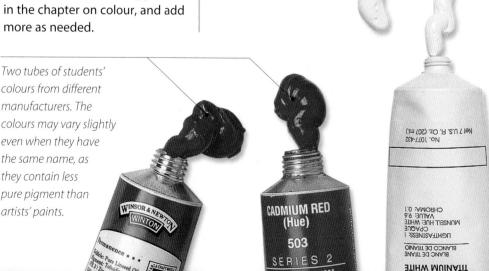

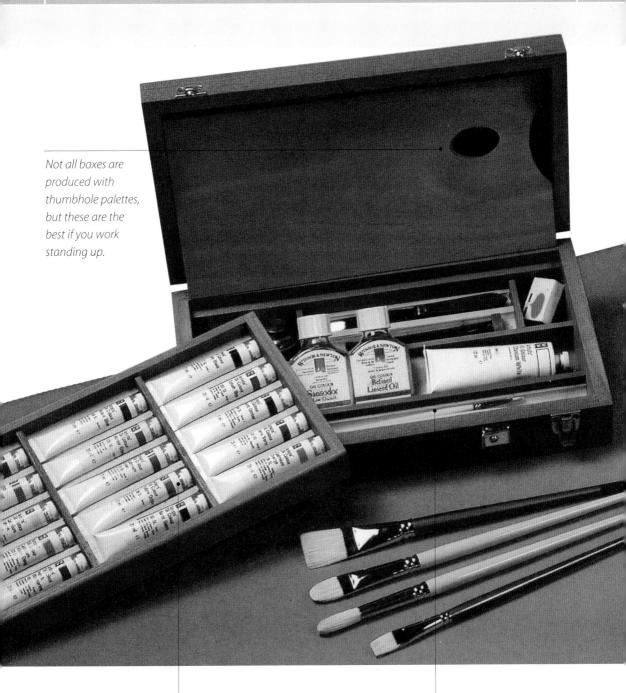

This box can accommodate about 15 standard-sized tubes of paint.

The long slot at the front of the box is designed for brushes, and will usually fit in a palette knife also.

Brushes

Bristle brushes (usually made of hog's hair) are specifically designed for oil painting. They have long handles, unlike the brushes sold for watercolour work, allowing you to stand away from the painting surface, and are made in a variety of shapes and sizes. The three main shapes are flats, rounds and filberts, all of which make distinctive marks, as shown opposite. Most artists also have one or two small round sable or sable-substitute brushes. which are useful for making preliminary drawings and adding fine detail in the final stages of a painting.

But you don't have to use bristle brushes if they don't suit your painting style. They are ideal for work in which the marks of the brush play an important part, but some artists like smoother effects, and prefer the nylon. long-handled brushes made for

> acrylic work. Start with a small range of brushes until you discover which ones will suit you best.

Rounds

Two sable and two bristle.

Sable rounds taper to a fine point, and are useful for details in the final stages of a painting.

Rounds, when held vertically, are ideal for stippling. They can also deliver long, continuous strokes.

Flats

One soft-haired (synthetic) and three bristle.

Flats make distinctive square or rectangular marks, much exploited by Cézanne.

Filberts

One soft-haired (synthetic) and two bristle. The hairs are quite long, arranged as a flat head and tapered to a rounded tip.

Filberts are extremely versatile brushes. They can leave rounded dabs of paint or be twisted during a stroke to create marks of varying thickness.

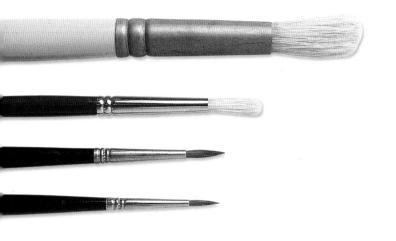

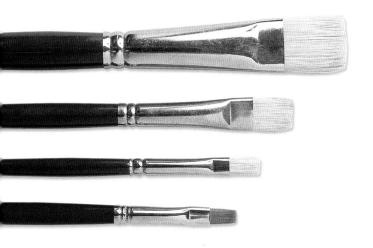

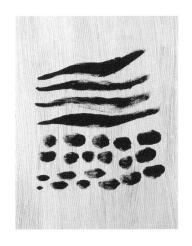

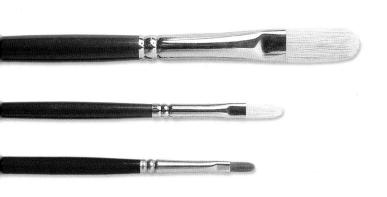

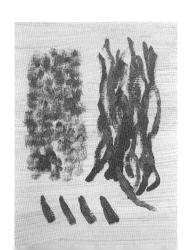

Palette and painting knives

A palette knife, made for cleaning up the palette and mixing large quantities of paint, is an essential tool in your starter kit. These are made in both plastic and steel, the former obviously being less expensive but also less durable. Painting knives fall into the category of specialist equipment, and may never be needed unless you want to experiment with the knife-painting technique. However, you may like to buy one of the small pear-shaped knives, since these are ideal for flicking on small highlights of thick paint.

A mahlstick is very useful indeed, and need cost nothing, since you can make one simply by wrapping a piece of rag around a bamboo cane. The padded end is rested on the edge of the canvas and your hand is supported by the stick, keeping it steady when painting small details.

Using a knife

Applying paint with a knife gives a very different effect to that of brushwork. Notice how the paint is squashed onto the surface, mixing into the colour below to create a streaky, ridged effect. Try out the method on a spare piece of board to see whether you enjoy it.

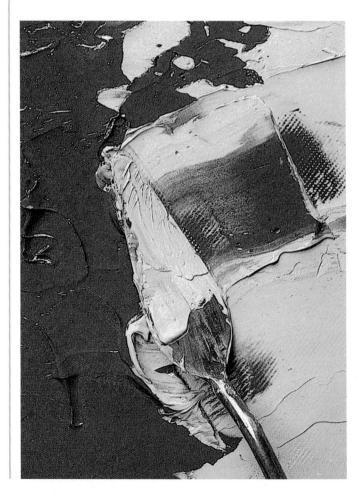

SEE ALSO

Knife painting, page 92

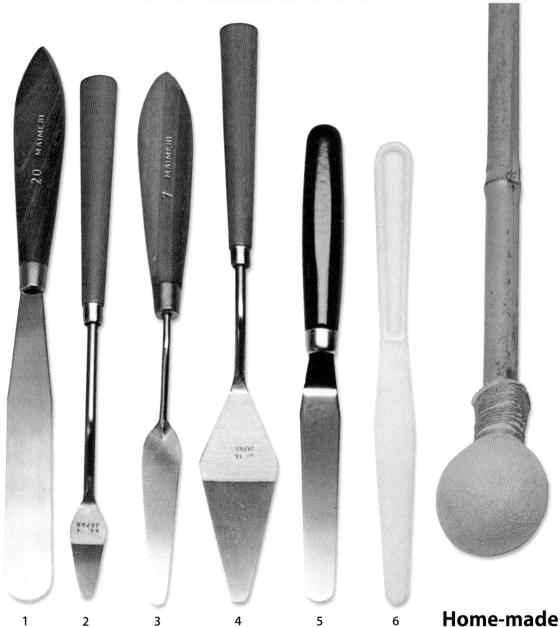

Types of knife

From left to right: a steel palette knife (1), four painting knives of different shapes (2-5) and an inexpensive plastic palette knife (6). Painting knives are also made in plastic, but only in a small range of basic shapes.

mahlstick

Mahlsticks are a great help for any work requiring precision and a steady hand.

Painting surfaces

Canvas is the most widely used support for oil paintings. It provides a sympathetic working surface, is light and easy to carry and can be removed from the stretchers and stored without taking up much space. However, there are many alternatives, a popular one being prepared painting board. This has a slightly greasy feel and does not hold the paint well, but some manufacturers produce a canvas board that is actually fabric stuck onto board.

Masonite is a useful support, and if you want a texture, you can stick canvas (or even old sheets and pieces of muslin) down onto it with wallpaper glue or acrylic medium. Both paper and cardboard can be used provided they are first sealed with a primer. You can paint on unprimed paper, but the oil will sink in to give a matt surface. Some artists like this effect, and Edgar Degas, who disliked the oiliness of the paint, habitually worked on unprimed paper or board.

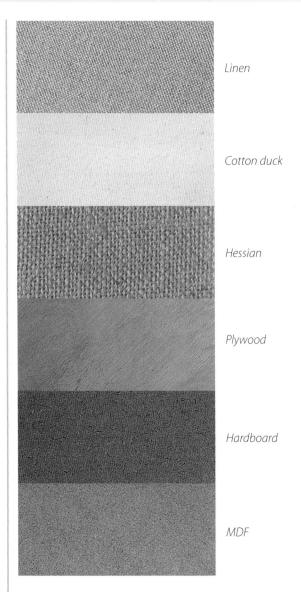

Canvas and board

Shown here is a selection of painting supports. The one you favour will depend on the particular surface quality you like, such as 'tooth' and springiness, so you may need to try out several before deciding which one suits your working method. Ready-stretched canvases are expensive, but you can stretch and prepare your own as shown on page 20.

Preparing board

Before priming a piece of masonite, either rub it over with glasspaper to remove the sheen and provide a key for the primings or wipe over the surface with methylated spirits to degrease it. You can either prime with an oilbased primer or acrylic gesso, the latter having the advantage of drying very fast. Whichever you use, you will need at least two coats. If you want a slight texture, apply the brushstrokes unevenly, following different directions.

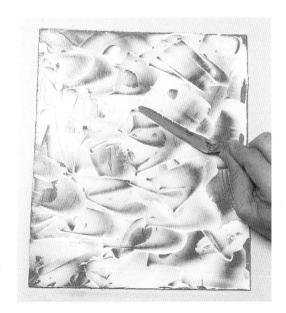

PVA glue, applied thinly in some areas and more thickly in others before muslin is applied, will give a varied final surface.

Varied texture

An interesting surface can be created by covering a board with muslin and PVA glue. Cover the surface of the board with the glue, applied roughly with a knife or scraper; don't worry about making it smooth. Take a piece of muslin 5cm larger than the board all around, press it down over the alue, fold the edges over to the back and stick them down. Then, apply glue unevenly over the muslin, covering it in places and leaving it bare in others. When dry, the board should be primed, and a coloured ground can be rubbed on lightly with a cloth. This creates a varied surface, smooth in some places, and with the weave of the cloth evident in others

Fabric supports for oil painting

Although a large variety of surfaces can be primed for oil painting, the traditional canvas, a term referring to a stretched fabric support, is still the most widely used. Different types of fabric can be used according to the tone and texture required. Linen has a fine, even weave and stretches reliably. However, it is relatively expensive, and cotton duck and calico have become

> widely used as and flax are suitable required.

280g (10oz) cotton duck No. 1

340g (12oz) cotton duck No. 1

425g (15oz) cotton duck No. 1

255g (9oz) cotton duck No. 2

Unbleached calico

Flax

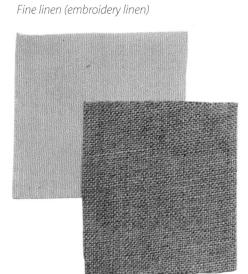

Fine artists' linen

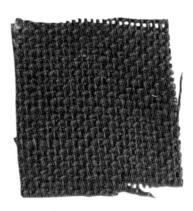

Coarse hessian

Prepared canvas

Stretching canvas

If you like to work on canvas but find the ready-stretched ones too expensive, you should consider stretching your own. This is not difficult, and also allows you to experiment with different textures (see page 16). Canvas for painting is sold in rolls by the larger art shops, and can also be bought from specialist suppliers. The stretchers themselves are also sold in art shops in standard lengths and are easy to assemble.

Canvas is normally primed before painting, with either an acrylic or an oil-based primer, but some artists like to exploit the natural colour of the fabric rather than painting on a white surface, and will simply put on a coat of size to seal the surface. The traditional size is rabbitskin glue, but you can also use clear wallpaper paste or matt acrylic medium. The latter is perhaps the best, but could work out expensive on a large canvas.

1 Make sure the assembled stretcher is properly joined at the corners by measuring across diagonally in both directions. If the measurements are the same, the corners are true. Lay the stretcher on the canvas and mark off the amount you need, allowing a 6cm $(2\frac{1}{2} \text{ in})$ overlap on each side.

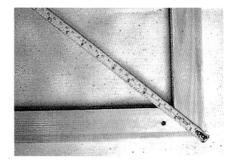

2 Cut the canvas to size, preferably using dressmaking scissors or pinking shears if you have them, since the latter will prevent fraying.

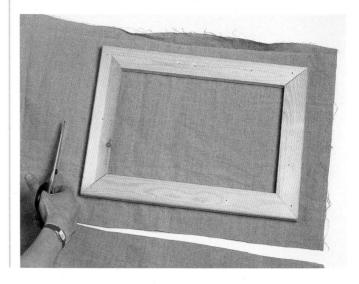

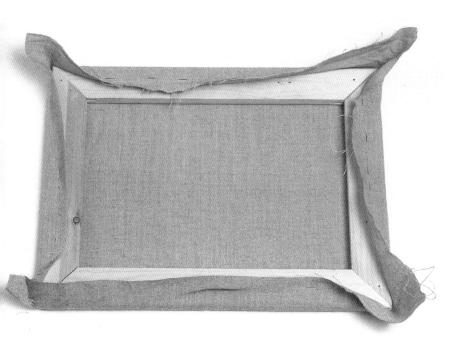

3 Working on alternate sides, staple or tack from the centre out to the corners.

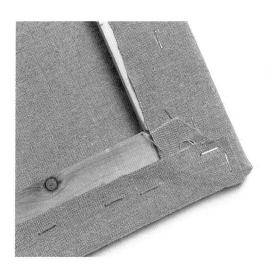

4 Staple each side before folding the corners over, and take care not to place the corner staple into the stretcher joint.

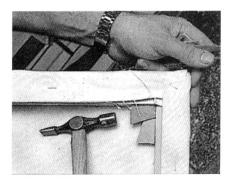

5 Insert the wooden (or sometimes plastic) wedges into the corner slots and hammer them in gently. You may need to tighten them again at a later stage if the canvas begins to sag.

Painting mediums

Oil paint can be used straight from the tube, but it is usual to mix it with a painting medium to make it more workable. The two

> commonest are linseed oil (also used in the manufacture of paint) and turpentine. The latter

thins the paint as well as making it dry faster, and is normally used in the early stages of a painting, and then mixed with greater quantities of oil as the work progresses. White spirit is sometimes thought to be an alternative, but is not recommended since it has no oil content and makes the paint look very dull, so save this for its main task of washing brushes. For those who are allergic to turpentine or dislike its strong smell, special odourless and non-toxic thinners provide an (expensive) alternative.

There are many other mediums sold for such purposes as bulking out the paint for impasto work, making it more transparent for glazing methods and varnishing when the painting is complete and fully dry. With all of these, be sure to read the manufacturer's instructions carefully before using.

SEE ALSO

Fat over lean, page 60

Mixing mediums

Paint mediums can be mixed easily and quickly. Recipes usually quote quantities in parts, and the easiest way to mix them is to use a jar or bottle with a tight-fitting lid and pour in the correct amount of each ingredient in turn, marking the level on the outside of the bottle after each addition.

> Mix ingredients in a jar with a tight-fitting lid.

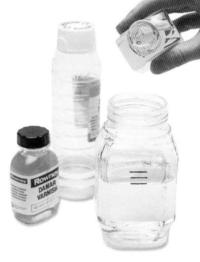

Thinned paint

These swatches show, from top to bottom: paint mixed with an impasto medium, paint mixed with linseed oil and paint thinned with turpentine.

Synthetic mediums

These help to reduce the drying time of the paint and change its consistency. The alkyd medium called Liquin is especially useful for glazing methods (see page 56).

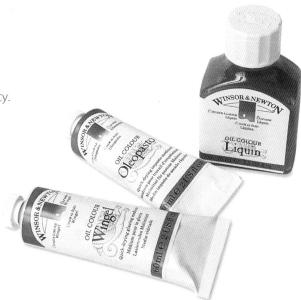

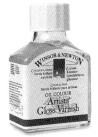

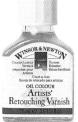

Varnishes

These are applied when the paint is fully dry. They protect the surface and help to revive areas of dull colour.

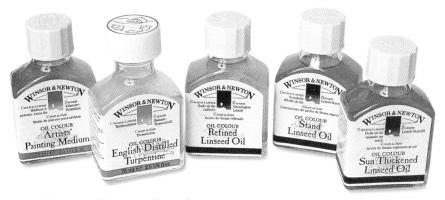

Drying oils and solvents

A large variety of products is available, but most artists start with refined linseed oil and distilled turpentine.

Bought canvases and boards are always white, which can be difficult to work on since it is not a 'real' colour – there are no true whites in nature – and it gives an artificial yardstick against which

to judge colours and tones. Many artists

tint, or tone, their grounds in advance by putting on a layer of colour over the white primer. Neutral

colours in a mid-tone, such as browns and greys, are usually chosen, and you apply them either opaquely or as a transparent stain. You can also use acrylics to apply a ground colour. This is convenient, since it dries much faster than oil paints.

Staining a ground

To apply a stain, choose a colour that is darker than the final result you want, thin it with turpentine or white spirit until it is quite runny and apply it all over the surface with a household brush. Before it has begun to dry, rub it down with a rag until it has the right degree of transparency. Alternatively, you can apply it with a rag rather than a brush.

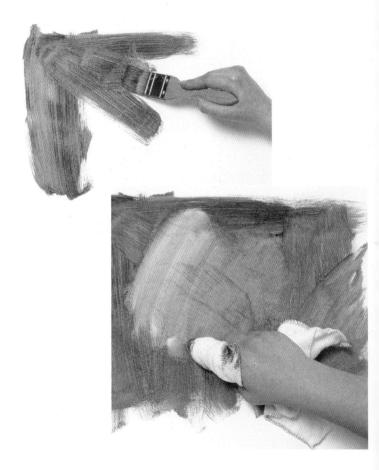

SEE ALSO

Coloured grounds, page 80 Underpainting, page 112

Choosing the right colour

Some artists like to have a ground colour that contrasts with the dominant colour scheme, painting a blue-grey snow scene on a yellow ground, for example, and others like a harmonizing colour. For the painting above, the artist wanted to keep all the colours warm, so they used a warm brown mixed from burnt umber and cadmium red, well thinned with white spirit and applied with horizontal brushstrokes. Notice the impact that this had on the finished painting (right).

Understanding colour mixing

Excluding white and black, there are only three colours that cannot be made from mixtures of other colours. These are red, yellow and blue, which are known as the three primary colours. Mixtures of two primaries, such as blue and yellow, which make green, are called secondary colours. But, as you can see from the colour wheel (below), there are different versions of each primary, and your secondary colour will depend on which red, blue or yellow is used.

The colour wheel

This simple wheel shows two versions of each primary colour, and the secondaries mixed from the two primaries to right and left of them. As you can see, the most vivid secondaries are made from the primaries that have slight bias towards each other. A bright orange, for example, is made from cadmium red, which leans towards yellow, and cadmium yellow, which has a slight red bias.

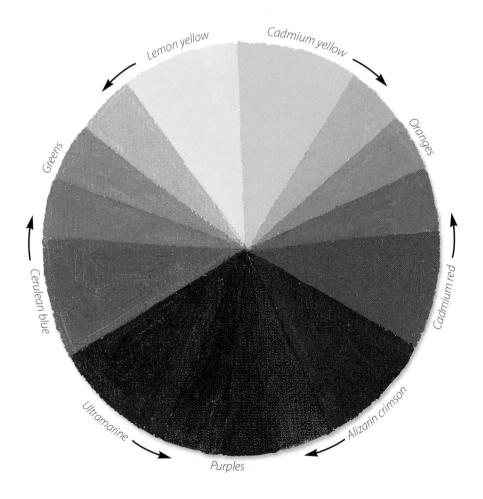

Although purples, oranges and greens (secondaries) can be mixed from primaries, it is not always possible to mix as vivid a secondary colour as you can purchase in a tube. Cadmium orange, for instance, is brighter than a mixture of cadmium red and cadmium yellow, and permanent mauve is brighter than most mixtures of blue and red.

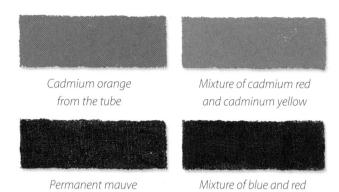

from the tube

Tertiary colours

These are the neutrals, such as browns and most greys, except those made with black and white. They are called tertiary because they contain all the three primary colours. This does not mean they are necessarily mixtures of three colours; they can be made from one secondary (i.e. two primaries) and one primary colour.

Cadmium yellow

Cerulean blue

These are four examples of the many mixtures that can be made from three primary colours. Variations can be achieved by altering the proportions, for example, more red will produce a stronger brown hue.

Complementary colours

These are the colours opposite one another on the colour wheel: red and green; yellow and purple; blue and orange. They are important in painting because they set up vibrant effects, but curiously, when these pairs are mixed together they cancel each other out, producing neutral colours.

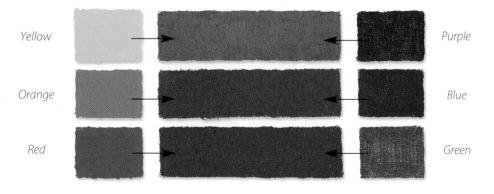

Opacity and strength of colour

When you are mixing colours, remember that different pigments have different properties – some are more opaque, others have more strength of colour. Strength of colour is not related to opacity. Alizarin crimson, for example, is very strong but transparent, while cerulean blue is weak but semi-opaque.

Degrees of opacity

Opacity affects paint's mixing capabilities, and if used unmixed, their ability to cover an underlying colour. Opaque pigments such as oxide of chromium green have strong covering power, while sap green is transparent, and instead of obliterating a colour below, it will modify it by adding its own quality. You can see some of these differences in the chart below.

Painted very thinly

Slightly thicker layer

Thick layer

Lemon yellow

Cadmium vellow

Rose doré

Cadmium red

Cobalt blue

Ultramarine

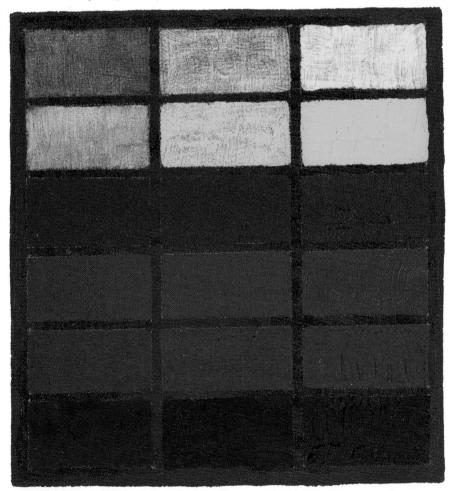

Adding white

When white is added to a colour it often has the effect of cooling as well as lightening it. As you can see from the chart (below), this is particularly noticeable with the reds, which changed from warm, vivid colours to quite cool pinks. This is because the warm end of the spectrum of light is partially blocked by the white pigment, leaving a higher proportion of cooler light rays (i.e. more blue).

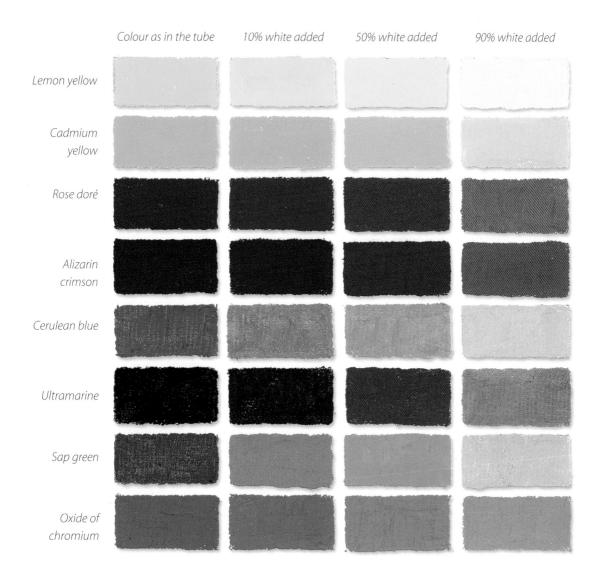

Choosing a palette

The word palette has two meanings: it is the surface on which you mix your paint, but it is also a term used to describe an artist's chosen range of colours. Here and elsewhere in this chapter it is used in the context of colour choices.

Although professional painters may have a palette of up to 20 colours, it is best to start with a small range initially, as this will give you valuable practice in colour mixing. You won't know what other colours you need until you have discovered what you

A basic range

You will always need two versions of each of the primary colours – red, blue and yellow – because even these colours vary in hue As you can see from the swatches here, there is a 'warm' and a 'cool' version of each one, and this 'colour temperature' affects the kind of mixtures you make. Six primaries plus a green and one or two earth colours such as yellow ochre, raw sienna, burnt sienna and raw umber – plus white, of course - will enable a wide range of mixtures. These colours are from a range of students' paints, which are relatively inexpensive and guite adequate for early attempts.

FOR ARTISTS COLIT ELID .

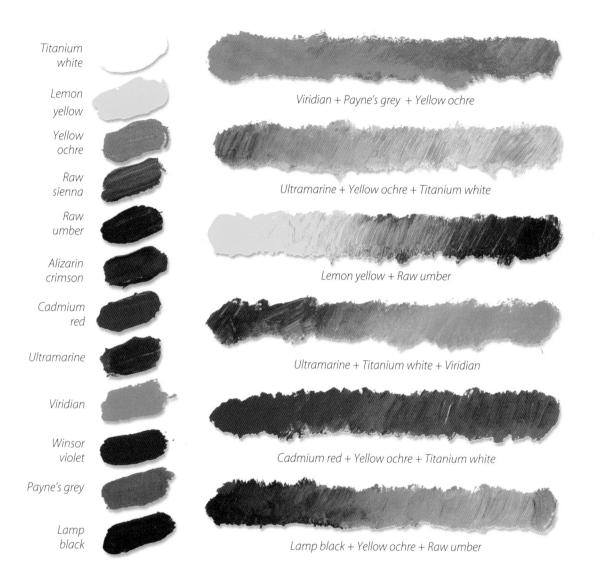

A personal palette

The choice of colours is always to some extent personal – all artists have their own favourites - and also depends to a large degree on the subject matter. These colours (above) are those habitually used by one professional landscape painter, but other artists working in the same genre might make different choices, and a flower painter would certainly have a larger selection of reds and purples, and possibly a ready-mixed orange.

Useful extra colours

Colour mixing is enjoyable but it can be frustrating when you find you can't achieve the brilliance of something in nature. When two or more colours are mixed together they are always slightly devalued, which is fine if you want a subtle colour but not good if you are trying to capture the glowing hues of flowers or the vivid green of a sunlit field. Sometimes you will find that a brushmark or two of pure colour straight from the tube brings your painting to life in a way that a mixed colour does not. Brilliant purples, for example, are very hard if not impossible to mix well.

Some of these 'special' colours are more expensive than the standard ones, since they can only be found in the artists' ranges and are priced according to the pigment used, but you may not need to use a lot of them, as you can reserve them for occasional accents among the more muted mixed colours.

Permanent rose A pure and brilliant red, slightly cool in hue, best used on its own.

Indian red Sometimes used as an alternative to alizarin crimson, very good in mixtures.

Purple lake Pure and strong, darker than the mauve below.

Permanent mauve A relatively light purple hue, useful for flowers.

Purple madder All the madder pigments are pure and brilliant.

Permanent magenta A slightly red-biased purple, impossible to achieve by mixing.

Indigo A very dark purplish grey, excellent in mixtures but use with caution as it has strong tinting power.

Winsor emerald Too vivid for most tastes, but can pep up mixtures and be used as accents.

Sap green A strong yellowish green, good in mixtures and for colour accents.

Olive green A subtle but punchy warm green, ideal for foliage.

Mixing greens

As mentioned on page 29, some secondaries are less bright than those bought in tubes. In the case of greens, however, certain mixes of blue and yellow produce very vivid hues.

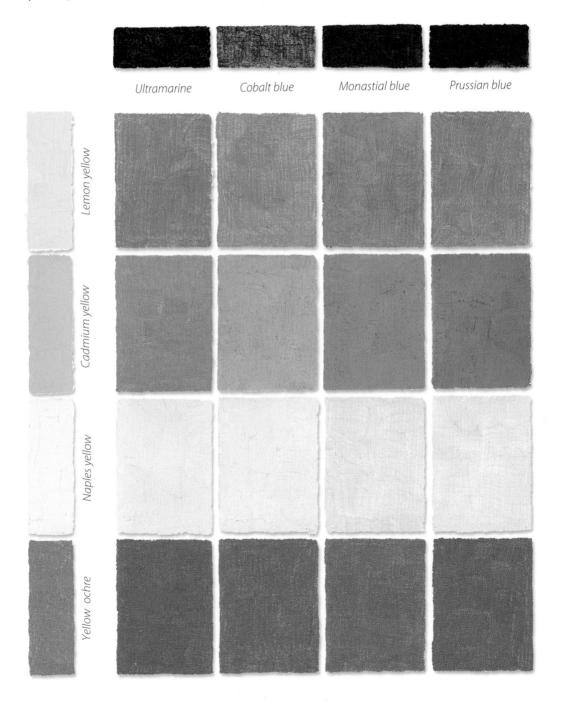

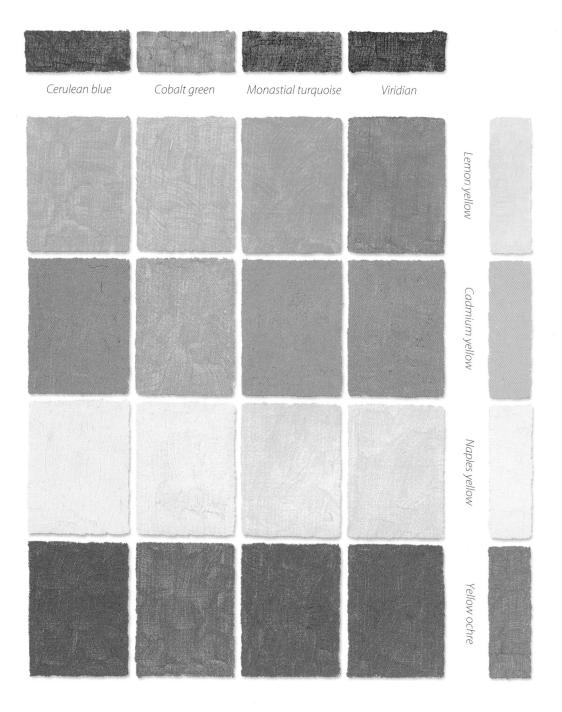

Using greens

Both the greens and yellows are slightly muted, but the painting is lively and full of movement, due in part to the contrast of small, linear marks of dark paint and broad slabs of colour. The picture was created using bristle brushes on canvas.

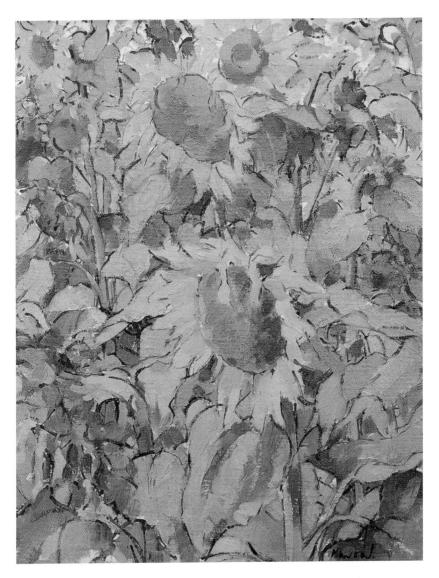

Robert Maxwell Wood

Sunflowers

Notice how the artist has created a focal point by painting the large flower in the centre in slightly more detail than the one above. He has also used brighter yellows, bringing it forwards in space.

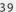

■ The greens used for the back of this flower were mixed from cadmium yellow, lemon yellow, ultramarine, cadmium green, cadmium red and cobalt blue. The stalk bears traces of cadmium yellow and a pale bluish green mixed from lemon yellow, cerulean blue and white.

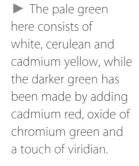

▲ The greenish browns in the centre of the flower are made from cadmium yellow, cadmium orange, ultramarine, viridian and cadmium red.

◀ These bright yellowish greens have been mixed from lemon yellow and cerulean blue.

Mixing browns

Browns are tertiary colours, a mixture of three primaries (see page 29). The chart below shows ways of mixing primaries, while the one opposite shows mixtures of reds with their complementary greens.

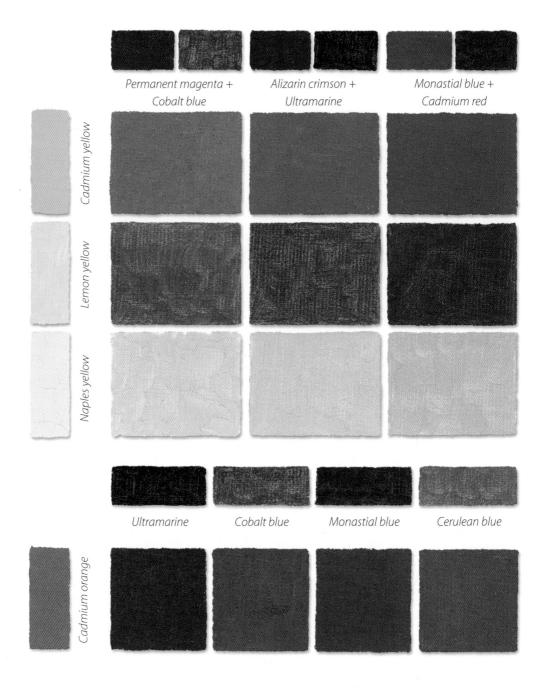

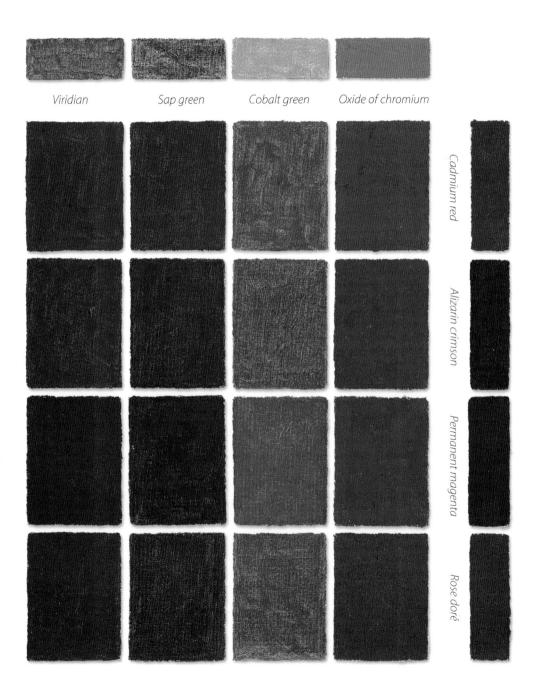

Using browns

Gerald Cains has used bristle brushes and painting knives for this work, and the paint has been applied thickly. To help it dry more quickly, a synthetic painting medium called Liquin was added. The composition was first blocked in with a knife and then completed rapidly during deteriorating weather conditions.

> Open strokes of colour have been used for this pale tree, painted with varying proportions of Naples yellow, yellow ochre, viridian, lamp black, cadmium red and white.

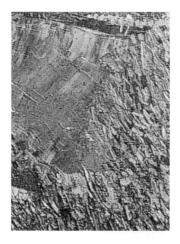

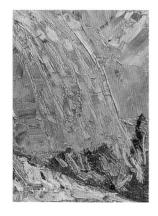

▲ For the ploughed strip at the top, mixes of ultramarine, Indian red, yellow ochre and white have been used, and the nearer field has been painted with viridian, Naples yellow and white, yellow ochre and white and small amounts of Vandyke brown.

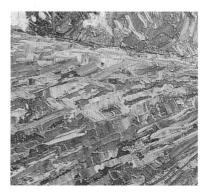

■ The foreground field's texture has been suggested with slabs and slashes of the painting knife, with the colours only partially mixed. The colours are Indian red, yellow ochre, cobalt blue, Vandyke brown, burnt umber and alizarin crimson.

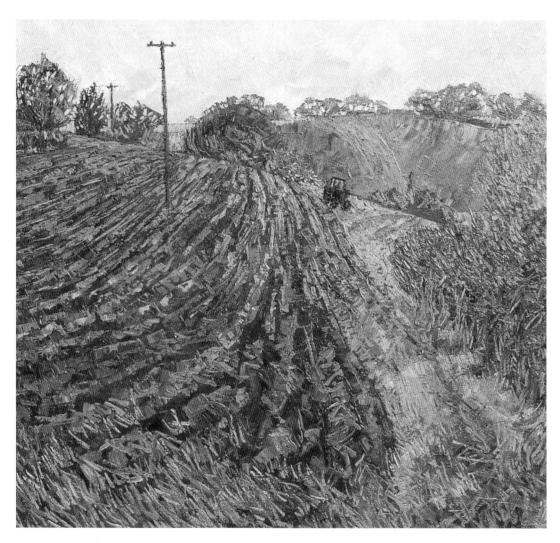

Gerald Cains

Autumn Ploughing

The energetic brush and knife strokes give a sense of movement and urgency to the painting. Notice how their directions and sizes are varied, with the fine marks for the grasses in the foreground crossing over the larger blocks of colour at the front of the field.

Oranges and purples are always a mix of two primary colours: red and yellow, and red and blue, with the results varying according to the primaries selected and the proportions in which they are mixed.

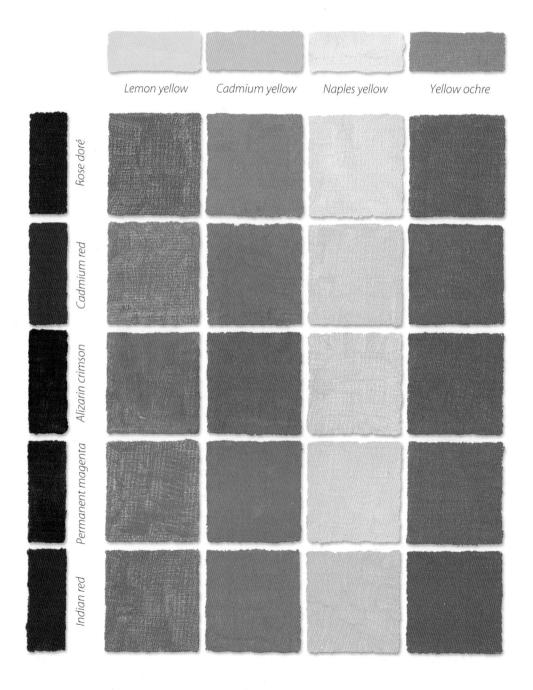

Mixing purples

Purple is one of the colours that becomes dulled in mixtures, so for really vivid hues it is better to use tube purples and magentas. However, mixes of blue and red can produce attractive if slightly muted purples and purple greys.

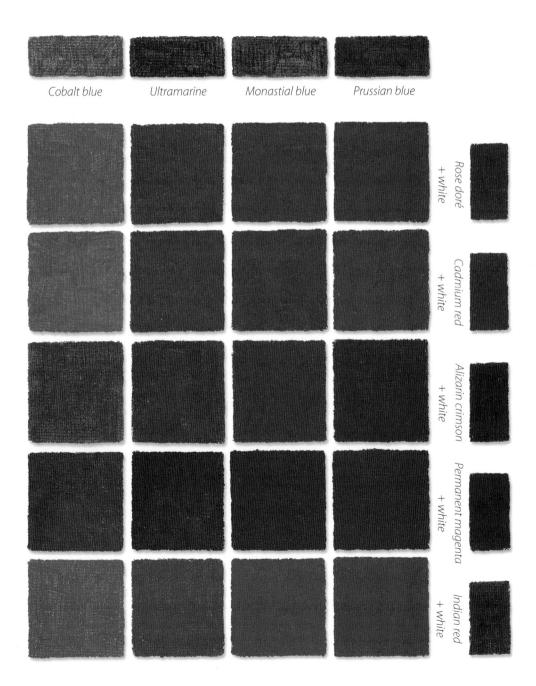

Using oranges and purples

This painting was done direct from the subject. It is on canvas, which was first given a warm pinkish ground made from Indian red, yellow ochre and white. An underdrawing was made in charcoal, and this was fixed before painting to prevent the charcoal muddying the paint. The painting was then completed rapidly to catch the fleeting effects of light and colour.

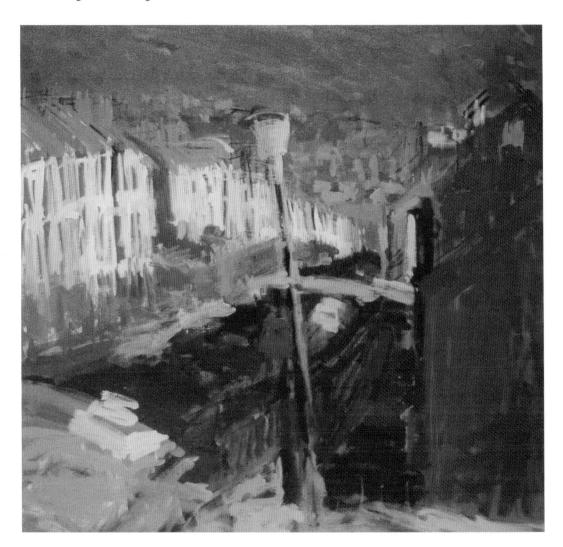

Stewart Geddes

Kensal Road

The buildings have been captured very rapidly and with great economy of means – a succession of vertical creamy white brushstrokes over darker paint suggest the windowed walls with no need for further detail.

▲ For this shadow area. mixtures of cobalt blue, permanent magenta, raw umber, Indian red and white have been used. A dashing stroke of ultramarine mixed with white contrasts with the more sombre purples and reds.

A mixture of Indian red and raw umber has been used for the deep shadow at the end of the terrace.

The side of the house is a mixture of Indian red and cobalt blue with a little white: the front of the terrace is chrome yellow and white; the rooftops are cadmium red, raw umber and white

◀ For the sky, permanent magenta, cobalt blue and white have been painted loosely over the pink ground, parts of which have been allowed to show through. The distant buildings are a mix of cadmium red, chrome yellow, Indian red, raw umber and white.

◀ For this very dark shadow, cobalt blue has been added to the Indian red and raw umber mixture. In front, chrome yellow with a little white highlights the pavement.

Mixing greys

Greys, like browns, are tertiary colours, and can usually be mixed from three primary colours. It is sometimes necessary to add a higher proportion of blue to the mix, since too much red will produce brown.

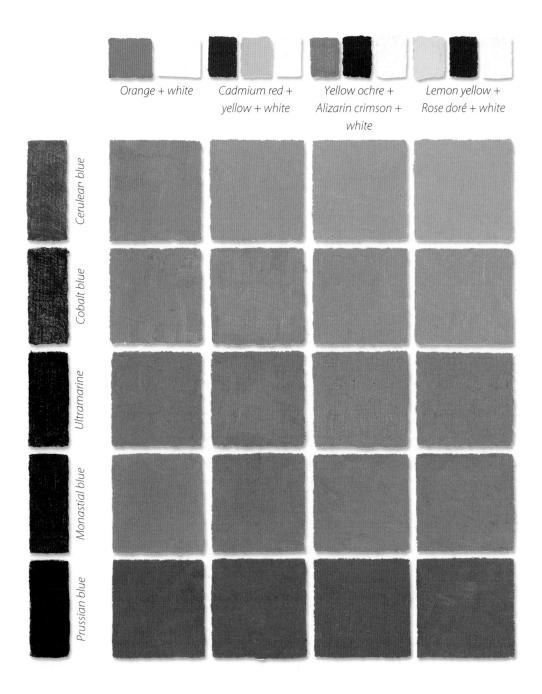

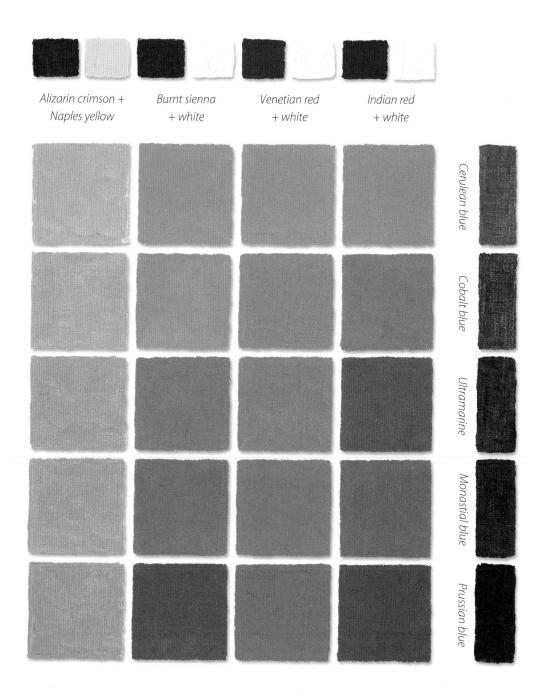

Using greys

This delightful painting has been done on canvas board using bristle brushes. Although the colour scheme is cool, a wide range of yellows and browns has been used – Naples yellow, lemon yellow, cadmium yellow, yellow ochre, raw sienna, raw umber and burnt sienna – and only one blue, ultramarine. The colour has been applied quite thinly, using pure turpentine with a little linseed oil. The colours are restrained and delicate, in keeping with the subject.

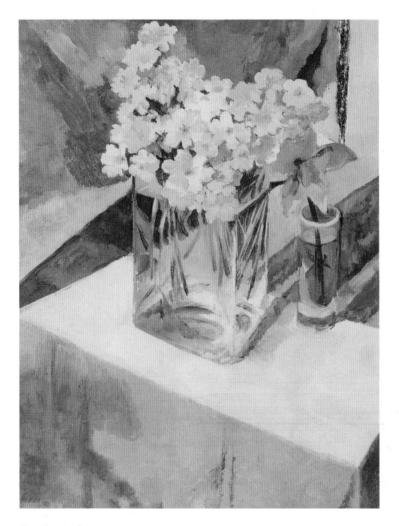

Eve Quarmby

Primroses

The painting disproves the idea that neutral colours are boring, but what gives strength and impact to the composition is the careful orchestration of geometric shapes, with the dark triangle behind the vase balancing the pale rectangle of the tabletop.

■ The yellow-brown ambiguous shape balances the downwards pull of the strong form just below. This corner, using greys mixed from ultramarine, raw umber, yellow ochre and white, is important in creating a gentle, intimate space around the flowers.

Yellow ochre, raw umber and white form the basis of the neutral yellowish drape. For the shadow, a small amount of ultramarine mixed with raw umber and white has been blended into the yellowish colour.

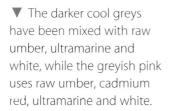

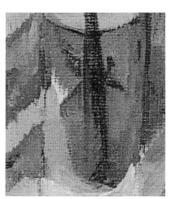

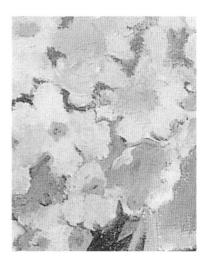

▲ The pale greys suggesting shade on the primroses have been mixed with ultramarine, burnt sienna, Naples yellow and white.

Mixing skin tones

The number of different words we use for describing the colour of skin – cream, peaches, gold, coffee, ebony, and so on – points to the fact that skin tones vary widely. In addition, the colours are affected by lighting conditions and surrounding colours, particularly of clothing. It is at least as important to pitch the tones (the lights and darks) correctly as to find the 'right' colours, and artists often take liberties

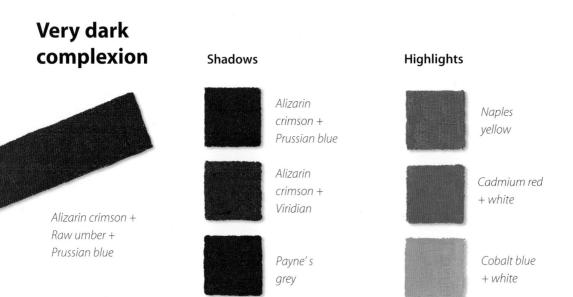

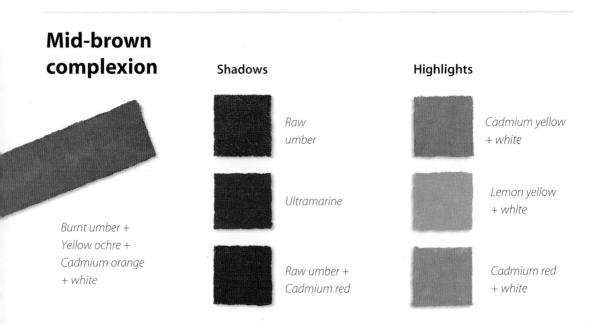

with colours to achieve effects that, while not strictly realistic, may enhance the appearance of living flesh. But although it is not possible to suggest a suitable palette for all skin, some suggestions can be made. Here we show four suggested basic colours, to which further colours can be added for shadows and highlights.

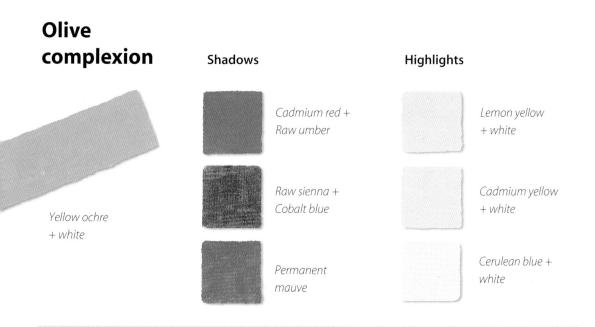

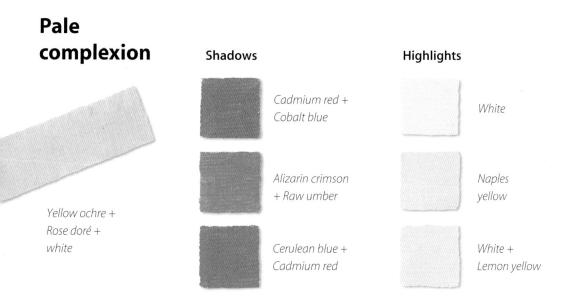

Using skin tones

This highly detailed portrait on canvas took several sittings. The composition was first drawn with a fine brush and well-diluted paint, and then built up gradually. To achieve the subtle variations of colour in the flesh tints, clothing and background, a fairly extensive palette has been used.

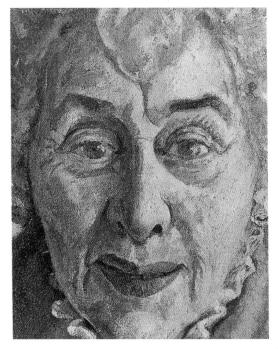

▲ The paler complexion of the woman was built up with mixes of rose doré, yellow ochre and white, and the shadowed sides are worked with strokes of raw umber, rose doré and cadmium red mixtures, with very small touches of magenta and cobalt blue.

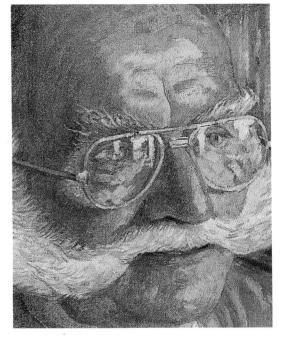

▲ The man's suntanned face has been painted with mixes of white, yellow ochre, Indian red, cadmium red, alizarin crimson and raw umber. Highlights contain more yellow ochre and white, and shadowed areas more raw umber plus an addition of burnt umber.

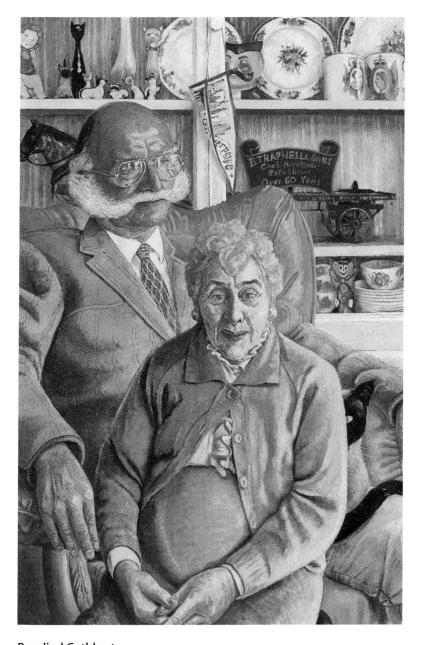

Rosalind Cuthbert

Ray and Moya Trapnell

The artist has created a sense of intimacy as well as a relationship with the viewer by posing the woman so that she is looking out straight at us, while the man focuses mainly on her, with his hand placed protectively on the arm of her chair.

In the early days of oil painting, colours were built up with transparent paint, used in a layering technique. Overpainting with transparent colours, called glazing, can be useful for modifying and adjusting colours already put down, and it also adds to the range of possible effects. You can glaze over thick or thin paint as long as the

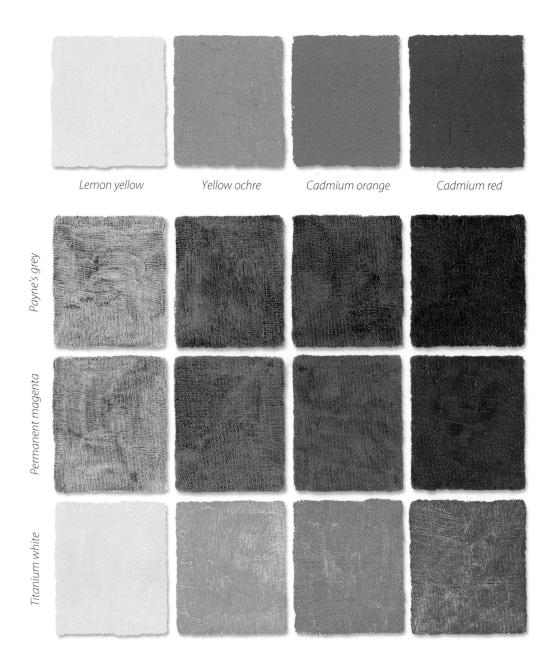

previous layer is completely dry. To make the colours transparent, they should be mixed with a special medium called glazing medium, available from most good art shops, not with linseed oil, since this thins the paint too much so that it dribbles down the surface. An alternative to glazing medium is an alkyd medium called Liquin (see page 23).

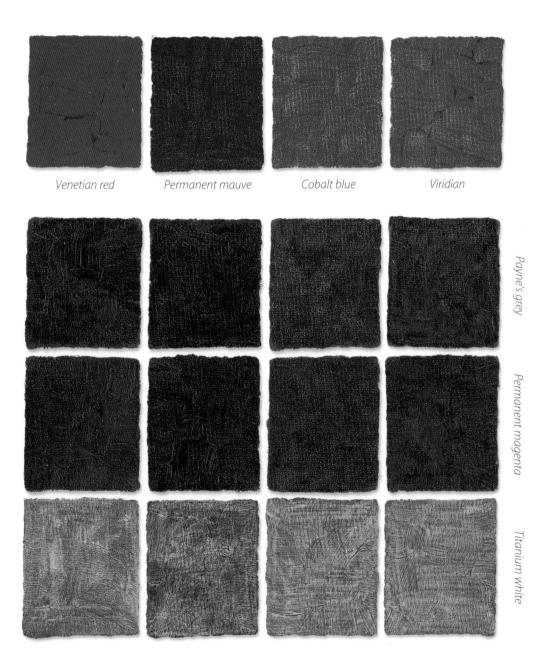

Fat over lean

Paint that has a high percentage of oil is described as 'fat'. 'Lean' paint is that which has been thinned with turpentine or white spirit only. The golden rule in oil painting is to paint fat over lean, and there are good reasons for this. The drying oils used both in the manufacture of paint and as a medium do not evaporate. They simply dry and harden on exposure to air, but this takes a long time (six months to a year to become completely dry). During this process the paint surface shrinks a little. If lean paint has been applied over oily paint the top layer will dry before the lower one has finished shrinking, and this can cause the hardened lean paint to crack and even flake off.

So, for any painting built up in layers the oil content should progressively increase. The usual practice is to begin with turpentine alone, or turpentine with just a little oil added, and add more oil to the mixture as the painting progresses. The final layer can be as thick as you like, and this is when artists sometimes add highlights in impasto (see page 88).

The blue paint on the left is lean, it has been well diluted with turpentine. The red paint, straight from the tube, has a much more substantial texture.

1 Some preliminary underpainting in thin, lean paint provides a basis for the application of subsequent layers of oilier paint.

2 The image is built up using slightly thicker paint, but this is less oily than that which will be used later.

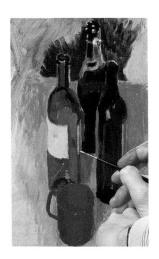

3 Apart from the danger of paint cracking as it dries, another reason for painting fat over lean is that it is difficult to add lean paint to a very oily layer. It does not adhere properly, so your brush tends to lift it off again.

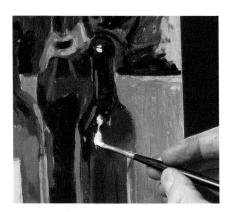

4 Fat white paint straight from the tube is applied for the highlights. This must be done last, since it would be impossible to paint further over these oil-rich patches with the paint still wet.

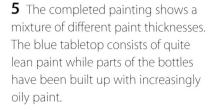

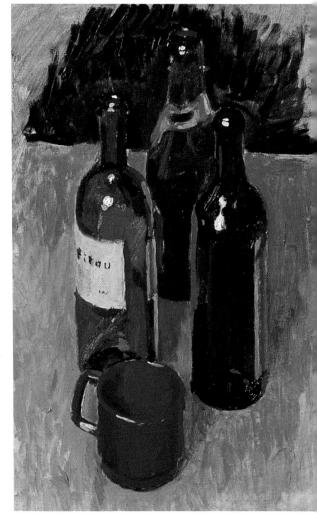

Alla prima

This is an Italian term meaning 'at first', and it describes paintings completed in one session. The essential characteristic of this method is that there is no initial underpainting as such (see page 112), although artists will often make a rapid underdrawing in pencil or charcoal to establish the main lines.

After the introduction of tubed paint in the mid-19th century, artists were able to work outdoors more easily. This plein air (open air) painting, as it is called, first undertaken by painters such as Constable, Corot and later the Impressionists, established the rapid and direct approach as an acceptable technique. Hitherto, oil painting had been largely a studio activity, as pigment had to be ground by hand, and paintings were built up slowly in a series of layers.

Working alla prima requires some confidence, since each patch of colour is laid down more or less as it will appear in the finished picture. Any modifications and reworking must be kept to a minimum so that the fresh effect is not destroyed.

1 Because it is difficult to get ellipses right, these were first drawn with pencil. The next stage was to block in some of the shaded areas with cobalt blue and the tablecloth with ochre, which helped to establish the feel of the composition. This photograph shows some of the basic colours being laid in with somewhat thicker paint. The colours are those that will appear in the finished painting, though minor modifications can be made as the work progresses.

2 The tablecloth has been loosely painted, and now the darker tones of the fruit are developed. The bold brushstrokes give a three-dimensional appearance.

3 The red stripe around the bowl is crucial to the composition, so it is painted next, in a mixture of cadmium red and alizarin crimson. A higher proportion of crimson is used towards the far side.

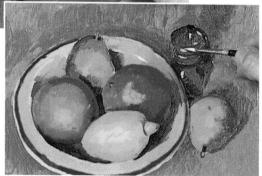

4 The tablecloth has been completed, and the shadows of the bowl, pepper shaker and pear added. A fine sable is used for laying small highlights on the pepper shaker in thick, undiluted paint.

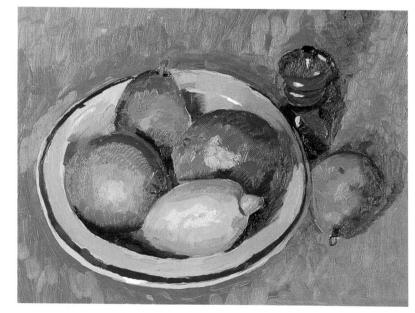

Blending

Blending is the process of merging one colour or tone into another so that no sharp boundary is formed. One of the best 'implements' to use for blending effects is a finger. Leonardo da Vinci was one of the great exponents of a technique called sfumato (from the Italian word for smoke) - rubbing with his fingers to achieve the impression of colours and tones melting into one another.

In most cases the colours to be blended will be closely related, as they will represent contiguous areas of a single form, and will mix to give a true blend of intermediate colours. Colours that mix to create a completely new colour cannot be blended satisfactorily; for example, blue cannot be blended with yellow since a band of green appears where the two colours overlap.

1 The sea towards the horizon is to be painted a dark bluegrey, but the area closer to the shore is to be much paler. Here these two colours are being mixed carefully, using

separate brushes. A third brush is used (below) to make an intermediate colour consisting of a mixture of the two original ones. Approximately equal amounts of the two paints are used for this.

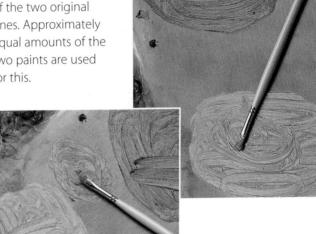

2 The three colours are applied to the painting, but are not yet allowed to touch one another. This ensures that no mixing or streaking of the paint occurs.

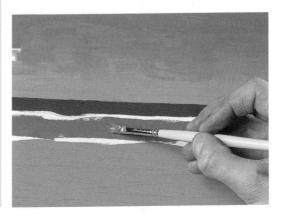

3 The bands of colour are now widened to meet each other prior to blending. The sky has already been completed, and blended to achieve soft gradations of colour and tone.

4 A clean brush is dabbed in a zigzag motion up into one layer and down into the next, carrying paint from one layer into the adjacent one and vice versa, forming a zone of dappled and crudely blended colour.

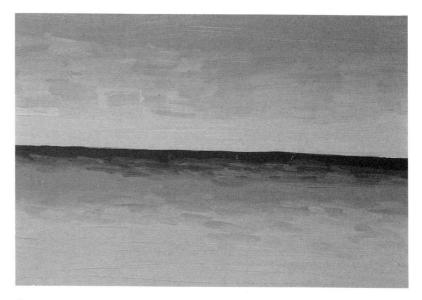

5 Some darker patches of paint have been 'pulled' further down into the foreground to give the impression of ripples. These echo the deliberately rough blending in the sky, which helps to unify the whole. In this case the boundary between sea and sky has been left unblended, but on a hazy day this area might also need blending.

Building up

The process of building a painting is largely an individual matter. Some artists like to cover the canvas as quickly as possible, and start with an underpainting in thin, diluted paint, which dries very quickly. This allows them to establish the main blocks of tone and colour.

Whether or not you follow this practice, it is always best to begin with the broad masses, concentrating on the main areas of shape and colour. If you are painting a portrait, for example, resist the temptation to begin by 'drawing' lips and eyes with a small brush - these details should be added only when the main planes of the face have been established. Another golden rule is never to bring one area of the picture to completion before another – always work over the whole surface at the same time so that you can assess one colour and tone against another.

1 The basic shapes are rapidly but carefully established with loose brushstrokes in wellthinned paint: cobalt blue, Payne's grey, raw sienna and cobalt violet. The white ground glows through this transparent paint.

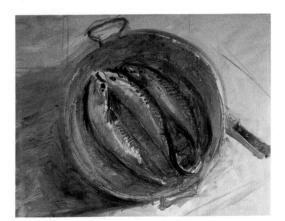

2 Having laid the foundations of the composition, the artist begins to develop the fish by building up with more opaque paint (mainly blues, greys and ochres with white). Notice how he works all over the picture at the same time rather than treating each area in isolation. More details are defined at this stage, such as the pot handles and the markings on the backs and eyes of the fish.

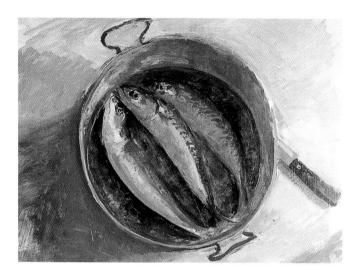

3 Further definition is given to the heads, and applications of thicker paint give more definition to the dark and light areas. Other details, such as the rim and handles of the pot, are clarified.

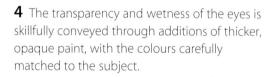

5 Following the principle of fat over lean (see page 60), each new layer of paint contains an increasing oil content. The artist might have chosen to continue with the painting – it is not always easy to know when to stop – but by this stage the fresh firmness of the fish were so beautifully captured that further work could have destroyed the spontaneity and liveliness of the picture.

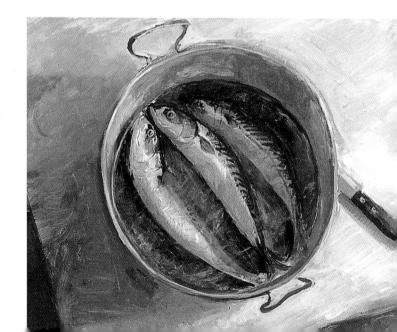

Underdrawing

It is not essential to make a preliminary drawing on the canvas, but if the subject is a difficult or complex one such as a portrait, figure painting or elaborate still life, it does help to have the various elements in their correct place, and even a simple landscape can benefit from a few lines to establish the main shapes.

Underdrawings for oil painting are often done with a small brush and diluted paint, but some painters like to use charcoal, which also enables them to block in tone as well as lines. The excess dust should be lightly brushed off and the drawing fixed to prevent it from soiling the paint.

For a detailed drawing a pencil can be more satisfactory, but if you are working on stretched canvas, avoid pressing too hard or you may pierce the ground layer.

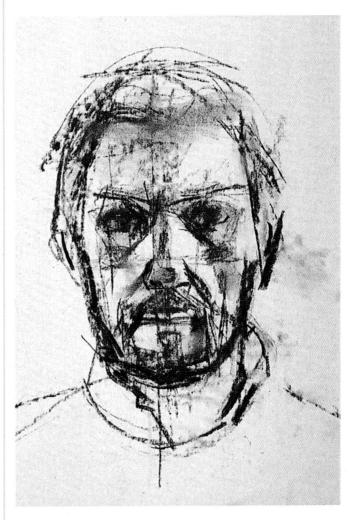

1 Drawing is vital in portraiture, you will not succeed unless you build your painting on a sound foundation. Here the artist has carefully laid the 'landmarks' of the sitter's face in charcoal, which is an expressive medium allowing both accurate, fluid lines and broad areas of tone. It is also easy to rub off, so that errors can be rectified before you begin to paint.

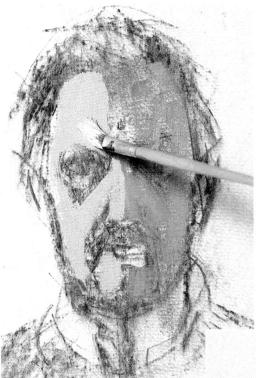

2 Once the drawing is completed, rubbed down and fixed, the artist can direct all their concentration on the application of paint without having to worry about the exact positioning of features.

3 Don't attempt to 'fill in' the outlines too slavishly: the drawing should act as no more than a guide. Here the brushwork is kept free and loose, with directional strokes used to block in the dark clothing.

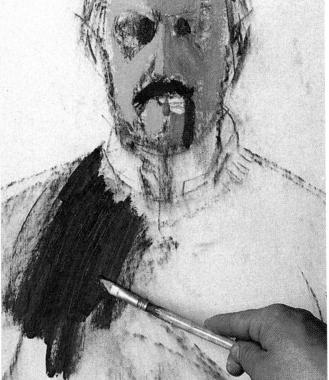

Brushwork

Because oil paint is an opaque medium, and can be applied thickly, brushwork plays an important part in the overall appearance of the painting. This has not always been the case; the artists of the Renaissance prided themselves on smooth surfaces and invisible brushmarks, but later painters such as Titian and Rembrandt began to exploit the marks of the brush, and the French Impressionists took the idea even further. Brushwork can be very helpful in describing forms and textures - for example, long, upward-sweeping strokes for a tree trunk and short dabs and dots for foliage – or it can simply be a means of adding interest to a large area of colour such as a clear sky. Try out different shapes of brush to find out the various marks they can make.

Large

filbert

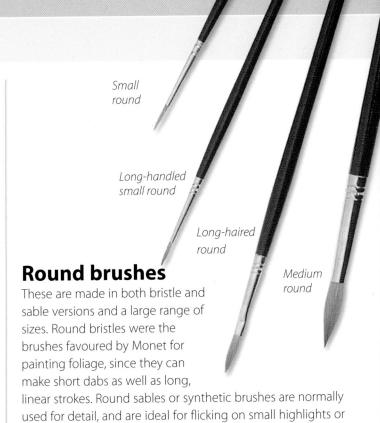

Filbert brushes

shadows to define shapes.

These are especially versatile since they can be used to make shaped strokes or turned on their sides for linear marks and detail. The larger sizes are useful for applying paint over large areas, as when blocking in. Flat brushes, known as brights, are also good for large areas, and ideal for thickly applied paint because they give a distinctive brick-like mark.

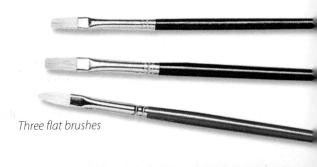

Descriptive brushwork

In Charles Sovek's Canyon Road Café, very loose, broad marks are used to depict different elements in the subject. Notice especially the foliage at top right, where the artist has restricted himself to just a few brushstrokes following different directions.

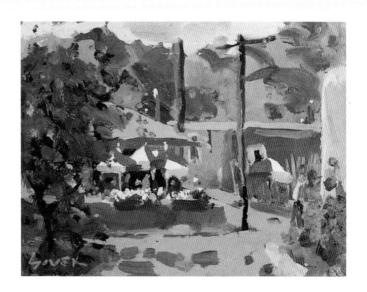

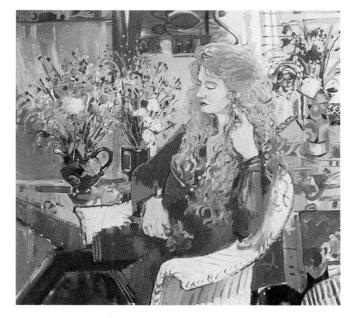

Varying the marks

Peter Graham has applied the paint in a number of ways in his Anne Amongst Flowers. Energetic vertical marks describe the figure and furniture, while long, flowing marks follow the direction of the hair. Both large and small strokes are used for the flowers

ARTIST'S TIP

If you find your brushwork becoming tight and fussy, it's a good idea to try to loosen up your style, and you can do this by choosing a brush size that seems to be too large for the subject. Choose a subject where detail is not over-important, such as a broad landscape, and try to capture each of the features with no more than three brushstrokes. You will find it hard at first, but it is worth persevering.

Analysis **Using brushwork**

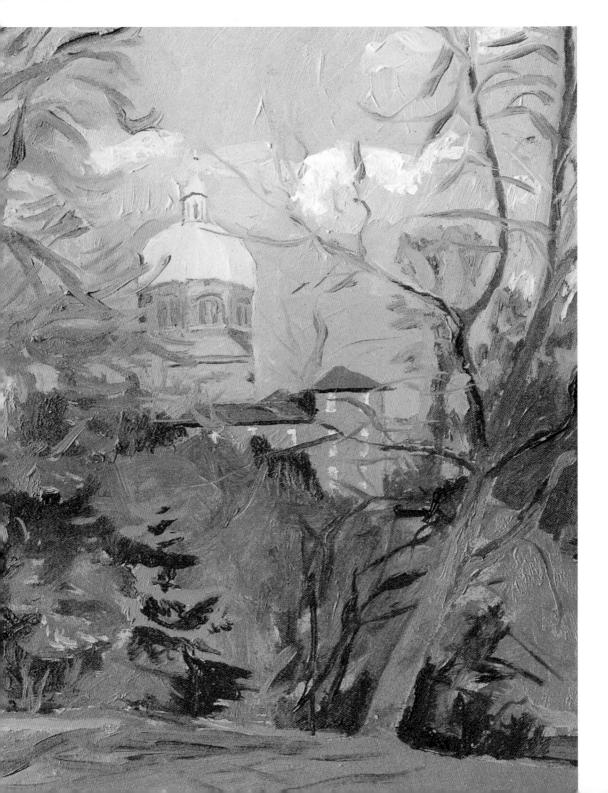

Jeremy Galton The Green Dome, Waterlow Park

This lively on-the-spot study shows a use of brushwork that is both descriptive and expressive. In general, the strokes follow the shapes and forms of the objects, with different sizes of brush chosen according to whether thick or thin strokes are needed, but the artist has also introduced brushwork into the sky, applying the paint thickly so that little ridges of paint catch the light. Working on location is a good discipline in the context of brushwork, because you have to work quickly, and will instinctively find ways of letting the brush 'have its head'.

Branches and foliage suggested with broad strokes made with a round bristle brush painted wet-in-wet over sky colours.

Brushstrokes follow different directions. and a little of the warm ground colour shows through to enliven the blue-grey.

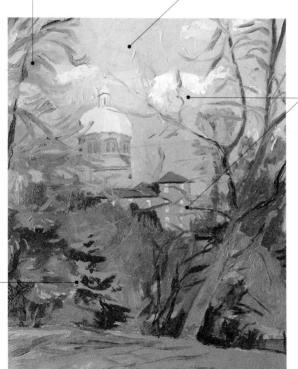

Whites painted over darker colours wet-in-wet so that they mix slightly.

Brushmarks of dull green provide a muted echo for the green of the dome, linking the two areas of the picture.

Dry brush

The dry brush technique is a method of applying colour lightly so that it only partially covers a dry layer of colour below. A minimum of paint should be used on the brush, and the brushstrokes should be made quickly and with confidence - overworking destroys the effect. Dry brush is most successful when there is already some existing texture, either that of the canvas or that provided by previous brushstrokes, and the layer of paint beneath must be relatively dry.

It is a useful method of suggesting texture, such as that of weathered rock or long grass, but like all 'special' techniques, should never be overdone or treated as a short cut.

1 The artist uses a fan brush to lay a scant overpainting of thick, undiluted paint. The bristles of this type of brush are well splayed and deposit paint in a light covering of fine separate lines.

2 The same technique has been used for the intricate pattern made by the branches of the small tree.

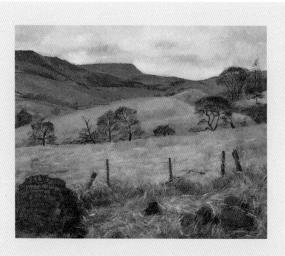

ARTIST'S TIP

Foregrounds are often tricky, but in Winter in the Peak District Hazel Harrison has solved the problem by the assertive painting of the weatherbeaten hay. It has been applied swiftly with relatively dry paint on a thin round brush.

Hard and soft edges

Ideally, a painting in any medium should show a contrast between hard and soft edges, or 'lost and found edges' as they are sometimes called. In a landscape, you will want softer edges in the background to create a sense of space, but even in a still life or flower painting some edges will be sharper than others, and you can stress a focal point by emphasizing these. It is easy enough to blur edges by blending colours into one another with a finger, but it is harder to produce crisp edges in oil paint than in watercolour or acrylic because it remains wet for so much longer.

However, if there is not too much buildup of paint, you can create shapes with well-defined edges simply by using brushstrokes of thicker paint and leaving them alone without blending.

Broken edges

1 If you want a broken effect, as for clouds, start by laying two or more colours next to each other.

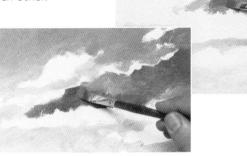

2 Mix them slightly by pulling one into another here and there, pushing the darker colour outwards.

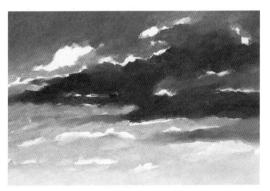

3 The mixture of hard and soft edges gives a realistic impression of depth.

ARTIST'S TIP

One of the best ways of painting edges is to lay one colour down with a stroke that runs in the same direction as the edge and then lay the second colour beside it, manipulating the brush so that the two colours butt up against each other.

Lay the second colour so that it iust touches the first but does not overlap it.

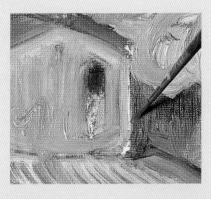

Blending with alkyd medium

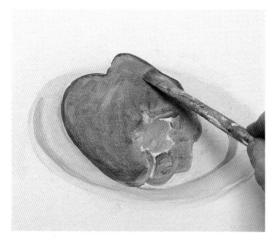

1 Paint can be made more fluid by adding an alkyd medium. This facilitates blending and also helps the paint to dry faster. Here the paint is applied with a nylon brush made for acrylic work.

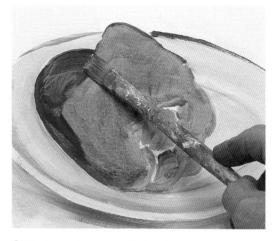

2 Darker colour is added with the same brush. You can judge the fluidity of the paint by the fact that it does not completely cover the colour beneath.

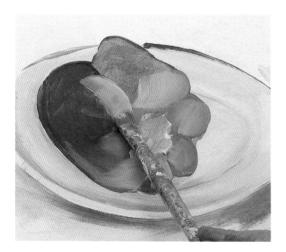

3 Lighter greens are applied and blended into the darker shadow on the right.

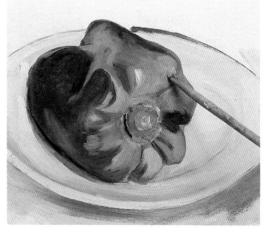

4 To define the form with more definite edges, the light paint is now used more thickly, without the addition of a medium, and a final small highlight is added.

Analysis Hard and soft edges

Hazel Harrison Charmouth Bay

This piece was painted wet-in-wet, and the hard edges on the cliffs were achieved through a combination of knife work and drawing into the paint with a pencil.

A lot of finger-blending was done in the sky area, especially for the beams of sunlight, and highlights were added with thicker paint at the tops of some of the clouds. The distant cliff was also blended with a finger to push it back in space.

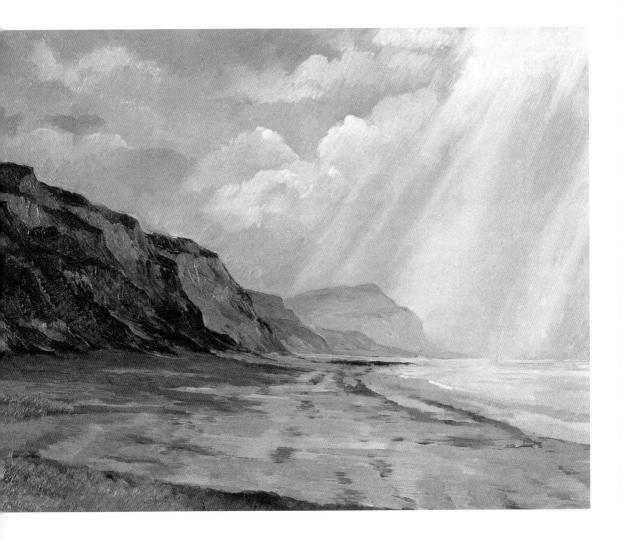

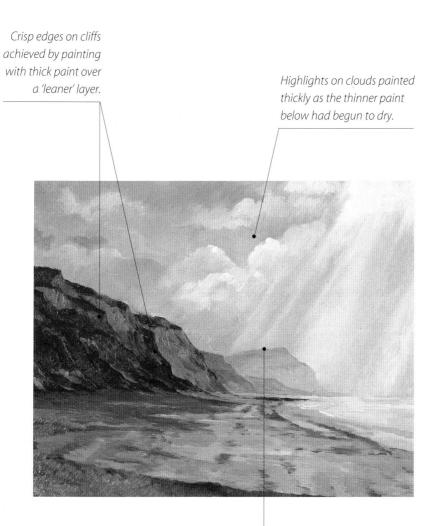

Colours blended with a finger to soften edges.

Coloured grounds

Some artists like to paint on pure white surfaces, but they can be inhibiting, particularly for beginners. It is difficult to assess colours against white, and there is a tendency to paint in too light a key, since almost any colour looks too dark by contrast. Another drawback is that when working out of doors the white surface can be dazzling, which can cause an over-hasty rush to obliterate all white areas.

A coloured ground (see page 24) will be closer to the average tone of the final picture, making it easier to judge both colours and tones from the outset. Midtones are the easiest to work on since you can paint towards light or dark with equal ease. If you paint over a very dark ground (called a bole) it follows that you will continually be adding lighter tones, culminating in highlights of thick opaque paint.

Another advantage of coloured grounds is that you can leave small patches of the ground colour showing between and around strokes, as pastel painters do (pastels are nearly always done on coloured paper). This helps to unify the composition, since the same colour is repeated from area to area.

1 The artist has chosen a mid-tone ochre ground as a basis for working towards both light and dark. He has begun the painting with the deep shadow areas.

2 One advantage of a coloured ground is that the painting never looks too 'unfinished', even in the early stages. This is especially helpful to the beginner, since it avoids the discouragement of large areas of unpainted white canvas.

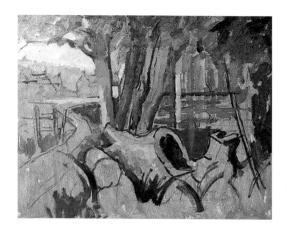

3 Patches of lighter paint have now been introduced. The artist will leave unpainted those areas approximating to the ground in tone and colour. At this stage it is possible to decide which they are to be.

5 Small areas of the ground remain exposed throughout the picture, their golden colour helping to unify the composition and contrasting with the cool greens and greys that might otherwise have become overdominant.

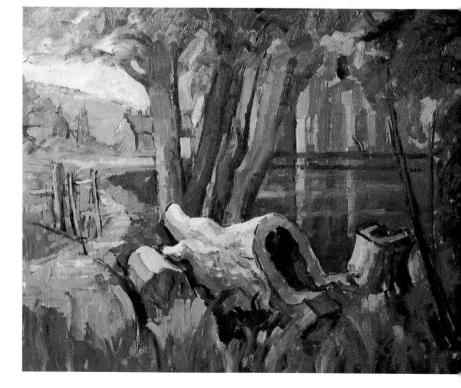

Wet-in-wet

This technique involves applying colours over and into one another while still wet, and it gives quite a different impression to working over a dry layer of paint. Because each new brushstroke mixes to some extent with those below or adjacent to it, the results are softer, with forms and colours merging into one another without hard boundaries.

Painting wet-in-wet requires a sure hand and no hesitation; too much reworking will destroy the clarity of your brushwork and may result in overmixed, and consequently muddy, colours. If the painting begins to look messy and lose its clarity the best course is to scrape it down and start again.

1 The pink roof is modified by the addition of grey, applied deliberately freely so that the wet colours will mix slightly. The degree of mixing depends on the thickness of the paint and the way it is laid on. The same medium should be used for each colour; in this case the paint is diluted with twothirds turpentine to one-third linseed oil.

2 All the colours used to paint this small area of farmhouse are being applied rapidly, one after the other. The white patch of wall has been painted into wet brown paint and some mixing has occurred.

3 Accuracy is essential when painting wet into wet since mistakes cannot be removed without destroying earlier good work. The artist steadies his painting hand by resting it on the other hand, which in turn has a secure hold on the easel.

Wet-on-dry

If you are completing a painting over a series of sessions you will probably find that you are painting wet-on-dry whether you planned it or not. Some artists, however, take a more methodical approach and deliberately allow each layer to dry before adding the next, perhaps in order to build up by means of methods such as glazing or scumbling (see pages 86 and 100).

In pre-Impressionist days, virtually all oil paintings were built up in layers in this way, beginning with an underpainting (see page 112) that established the drawing and tonal structure. It is not a technique for recording quick impressions, but is highly suitable for more complex compositions where there are many different elements, since it gives a high degree of control over the paint.

It is important to think of each layer as the prelude to the next, and to build up gradually to achieve the contrasts between light and dark areas that will give depth to the painting. The usual method of working – but not the only one – is from dark to light, keeping the paint thin in the initial stages and reserving the thicker highlights until last.

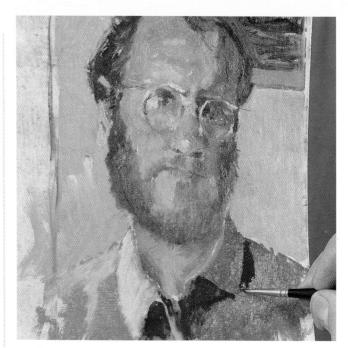

Crisp detail

Considerable precision is possible with the wet-on-dry method, since the paint does not mix with the layer below as it does when working wet-in-wet. It is thus ideal for the crisp detail added in the final stages of a painting. The slightly blurred effect seen on the shirt and face here is due to earlier tonking (see page 102), a method often used for portraits.

Combining techniques

In Juliette Kac's Oranges there is a combination of both methods, with the tabletop and inside of the bowl worked wet-in-wet and the crisp edges wet-on-dry. There is an element of collage in this picture: the newspaper is not painted but real.

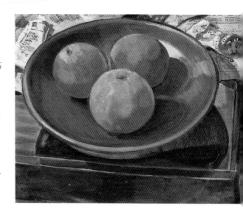

Corrections

One of the advantages of working in oils is that corrections can be made easily either to the whole painting or to small passages. Wet paint can simply be scraped off with a palette knife. This may leave a ghost of the previous image, which can either be retained to act as a guide for the fresh attempt or removed with white spirit on a rag. If a painting becomes unworkable through too heavy a build-up of paint, the top layer can be lifted off by blotting with absorbent paper (see Tonking, page 102).

In the case of a painting built up in a number of layers, you can facilitate later corrections by rubbing a little linseed oil into the previous dry layer before adding more colour. This is called 'oiling out', and it not only assists the application of wet paint but also makes it easier to remove.

An area of thin dried paint that requires correction can simply be overpainted, but existing paintwork can be very distracting if small modifications are being attempted. It may be better to either sand down the offending area, which will remove at least some of the paint, or paint a new ground over this patch and start again.

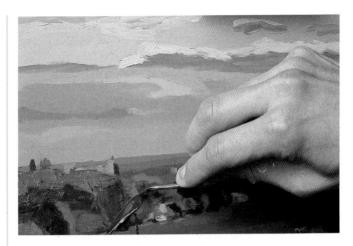

1 Much of the paintwork at the lower left is unsatisfactory and has become thick and unworkable. It is thus removed, initially by scraping off with a small painting knife.

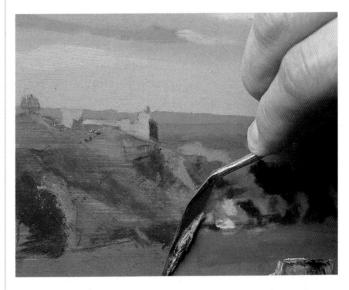

2 Scraping back leaves a ghost of the original image that can often form a helpful base on which to rework (see also Tonking, page 102).

3 If desired, scraped-back paint can be completely removed with a rag dipped in white spirit or turpentine, as here.

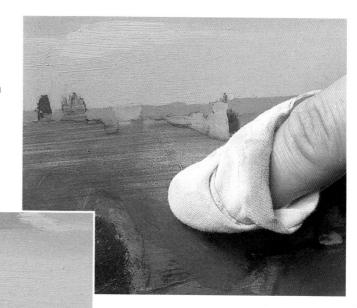

4 The area is now reworked. Corrections such as these are easy to make when the paint is still wet.

ARTIST'S TIP Dry paint can be removed with sandpaper as long as it is not too thick.

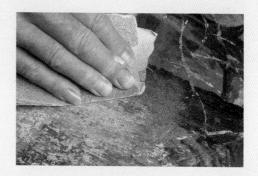

Glazing

A glaze is a thin layer of transparent paint laid over a dry layer, which can be either thick or thin. Since the lower layer is visible through the glaze, the effect is quite different to anything that can be achieved with opaque paint.

The Renaissance painters achieved their wonderful glowing colours by glazing layer over layer of transparent paint, using little or no opaque colour, and the glazing method was also used by JMW Turner to achieve his luminous skies and landscape effects, sometimes glazing over thick, opaque paint.

Because a glaze alters the colour of an underlying layer, it can also serve as a method of colour mixing, for example, a transparent ultramarine blue glaze over yellow produces a green, while a glaze of alizarin crimson over blue will make purple. A number of these exciting effects are shown on page 56.

The best mediums to use for glazing are the modern synthetic ones sold especially for the purpose. Linseed oil is not suitable, since to make the paint transparent you will have to add a great deal of oil and it will simply run down the support or merge with adjacent glazes.

Glazing medium (top) and mixed with paint (below).

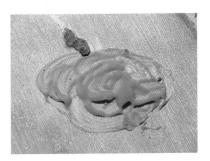

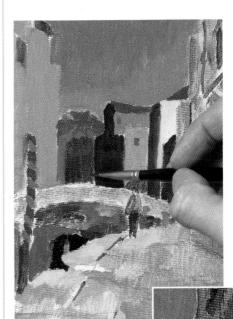

1 The underpainting (see page 112) was left quite pale so that it could be built up by glazing. Here the distant red house is being glazed with alizarin crimson.

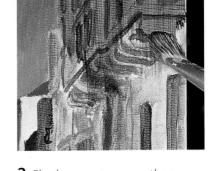

2 Shadows cast across other distant buildings are glazed. Details can be added later within the glazed layers.

3 The detail already painted remains visible through the purple glaze.

4 The large, bold shadows of the foreground and to the right of the picture demonstrate the usefulness of glazing as a technique. The previously painted detail is not obscured, and the colour of the underpainting shows through the glaze, giving it a particularly rich effect.

Impasto

This term describes paint that has been applied thickly enough to retain the marks and ridges left by the brush or painting knife. The ability to build up oil paint is for many people one of its main attractions, since the picture surface acquires a threedimensional quality that can be used to model form and even mimic the texture of the subject.

The paint can be applied with a brush or painting knife (see page 92) for impasto work, or it can even be squeezed out straight from the tube. If the paint is too thick, a little linseed oil can be added, and there are also mediums especially made for impasto work, which act as extenders, bulking out the paint. For anyone working on a large scale, impastos are very helpful, since they can halve your paint costs. They also speed the drying process, which is an important consideration when more layers of paint are to be added.

1 So far only a fairly thin layer of paint has been applied. The brushwork is rather monotonous and the picture lacks vitality, so the artist decided to introduce some eye-catching accents.

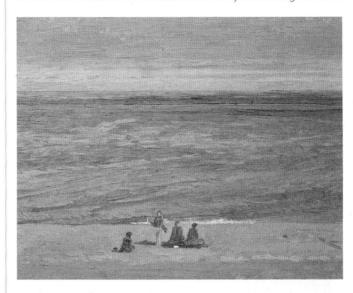

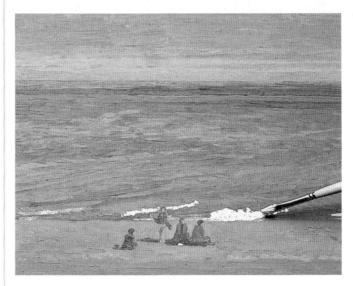

2 Thick, pure white straight from the tube is dabbed in place with the point of a round brush to represent foaming breakers.

3 Some yellow ochre 'pushed' into the white suggests churnedup sand, while the grey provides shadows below the tops of the breakers. Finally, a thin sable brush is used to lay cadmium red impasto as a foreground accent.

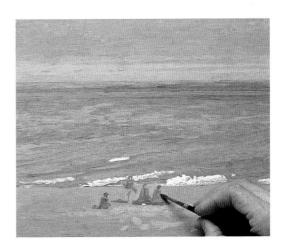

4 The whipped-cream quality of the impasto can be clearly seen in this painting. It will not change as it dries - one of the unique characteristics of oil paint.

Analysis Impasto

David Curtis An Inlet Near Morar

Brushwork is extremely important in David Curtis's work, and in this painting, the paint has been used thickly enough to hold the marks of the brush while still retaining its fluidity. He likes to exploit the buttery nature of the medium and to exploit thick-thin contrasts. Notice how the background has been painted relatively thinly wet-in-wet (see page 82), effectively pushing the area back in space, while the thick touches of impasto on the prows of the boats, the mooring ropes and the planks of wood both define the shapes and emphasize the spatial relationships. Strong contrasts of tone in the foreground also pull the area forwards to the front of the picture plane.

> Medium-consistency paint worked wet-in-wet so that the colours partially blend.

The thick paint has a physical presence that makes it stand out from the surrounding areas.

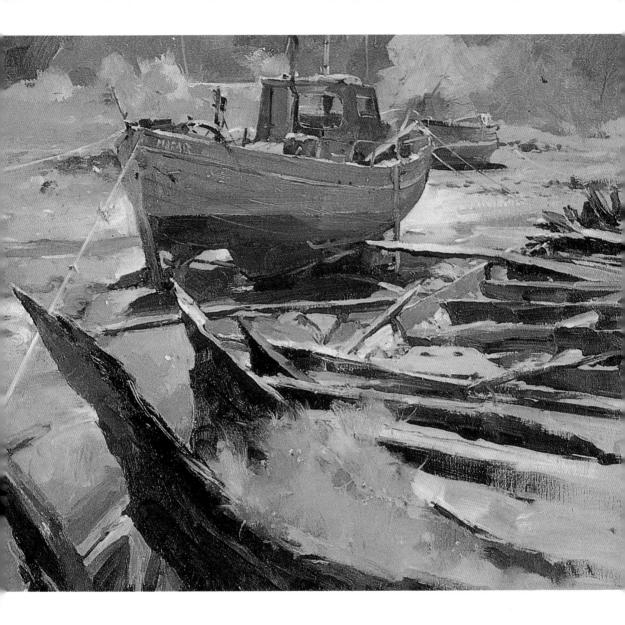

Knife painting

Applying thick paint with knives gives guite a different effect to applying thick paint with brushes. The knife squeezes the paint onto the surface, leaving a series of flat, smooth planes, often bordered by ridges or lines where each stroke ends. It is a versatile and expressive method, ideal for the artist who enjoys the sensuous, 'hands-on' aspect of mixing and applying thick, creamy paint, although initially somewhat trickier than brush painting. The marks can be varied by the direction of the knife, the amount of paint loaded onto it, the degree of pressure applied, and of course the knives themselves.

Painting knives (see page 14) have cranked handles and extremely flexible blades of forged steel. They are made in a wide variety of shapes and sizes from large straight ones to tiny pear shapes ideal for flicking paint onto the surface. However, care must be taken not to build up the paint too thickly; it may crack if it is more than about 5mm ($\frac{1}{4}$ in) thick at its maximum.

1 Thick paint is smeared onto the surface in a sideways sweep of the knife. The paint has been mixed with an impasto medium to bulk it out.

2 The picture is built up over a rapid drawing done in thinned paint. Any form of underpainting would be pointless because it would be completely obscured by the layers of impasto.

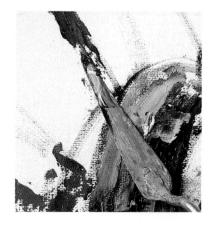

4 The picture is built up gradually, rather in the manner of a jigsaw. Each new colour is well mixed before application.

5 Each separate patch of colour joins with its neighbours to form a near-continuous covering of paint. The final texture of smeared and ridged paint has a lively, sparkling quality.

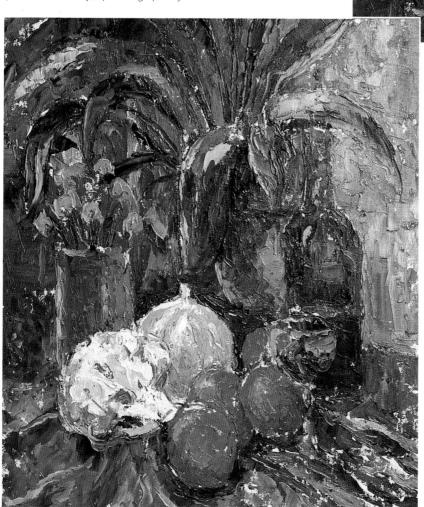

Analysis Knife painting

Jeremy Galton San Giorgio Maggiore, Venice

Knives are often only used for certain parts of a painting such as final accents and highlights, but in this work the whole picture has been built up with painting knives, giving a lively surface texture. It is a technique well-suited to architectural subjects, since considerable precision can be achieved with the smaller knives, though the method does require practice and a sure hand.

> Knife strokes make small ridges that catch the light.

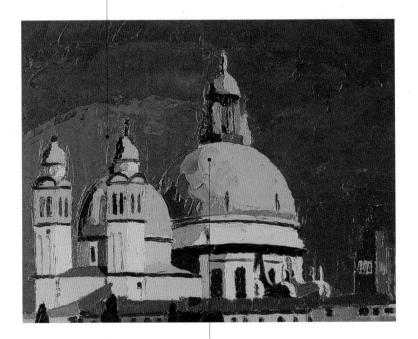

Distinctive marks made with a pear-shaped painting knife.

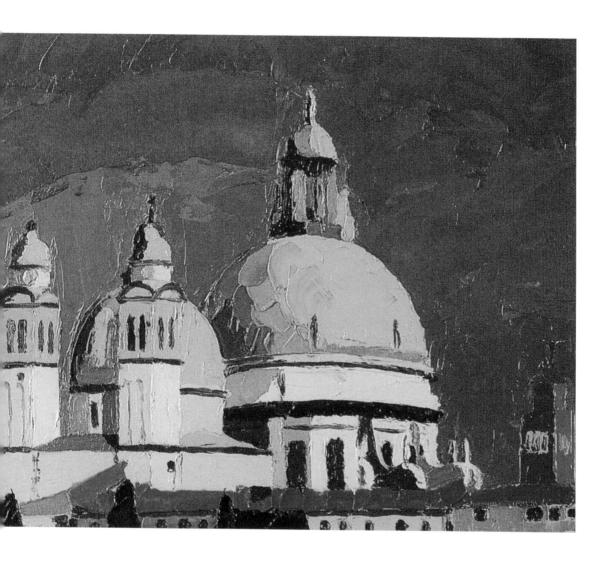

Finger painting

This is perhaps the most natural, and certainly the most direct, method of applying paint. The fingers are sensitive tools and are often superior to either brush or palette knife for subtle effect and fine control of paint thickness.

The fingers and hand are particularly useful for the rapid application of undiluted paint over large areas, since it can be rubbed well into the canvas fibres to give a greater degree of adherence. Paint can also be smeared off by hand until it is at its desired thickness. When modelling rounded forms, as in portraiture or figure painting, this technique can be invaluable, since it allows you to obtain very smooth gradations of colour and tone in which the underlying layer shows through as much or as little as you want it to.

1 A combination of fingers and brushes is to be used for this painting. Having blocked in the basic features in paint mixed with alkyd medium (see page 22), the artist blends them with her finger and then adds further thin layers. She is careful to keep the colours very close in tone so as not to lose the misty atmosphere.

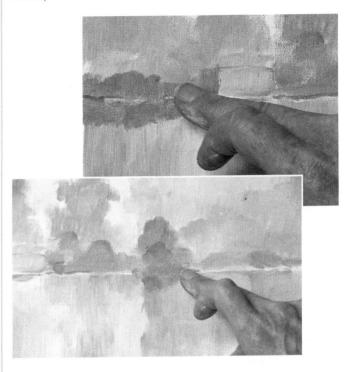

2 Layer upon layer of pale colours are rubbed into one another in the sky area to produce a luminous effect. The trees, in contrast, are blended to a lesser degree to retain their pale but distinct outlines.

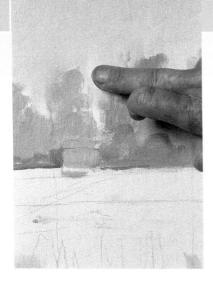

3 The contours of the distant trees are smudged into the sky so that they appear to recede from the viewer.

4 The water, like the sky, is built up with many thin layers of paint. The thickness of the paint can be very precisely controlled by the finger method, and in this case it becomes both thicker and darker towards the bottom of the picture.

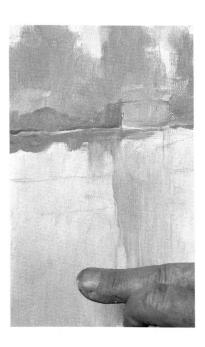

5 The finished picture has a wonderfully atmospheric effect. Handling the paint with the fingers has helped to ensure that the ethereal quality of the scene is maintained throughout. The picture has been painted in a limited colour range and in a high key – that is, only pale colour mixtures have been used.

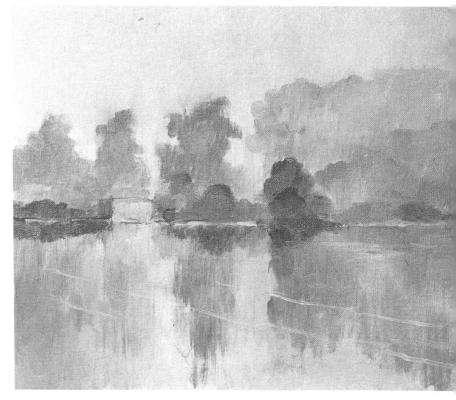

Sponge painting

Applying paint with a sponge gives a more rugged texture than brush applications and can be a useful way to cover large flat areas. Natural sponges give an interesting open pattern, although they will not last long under these conditions. Synthetic sponges have a finer, closer texture, which could be ideal for the rendering of clouds, foliage or foaming water. Sponges can also be used to lift paint off the surface.

Whatever kind of sponge is chosen, it should be turned and struck from different angles to give the texture some variety and prevent a monotonous repetition of the imprint. By superimposing two or more layers you can create optical colour mixtures and interesting broken colour effects.

Painting clouds

1 White paint is dabbed onto toned primed card with a synthetic sponge. The texture of the paint is open and diffuse.

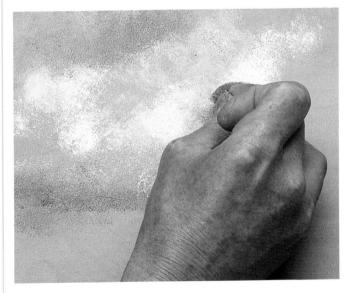

2 The sponge is now used to apply blue and grey paint, which smoothly blends in without sharp boundaries.

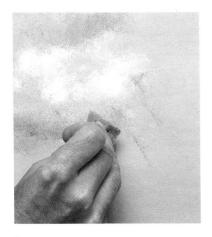

3 The ground still shows through the new veil-like covering of paint.

Using the canvas texture

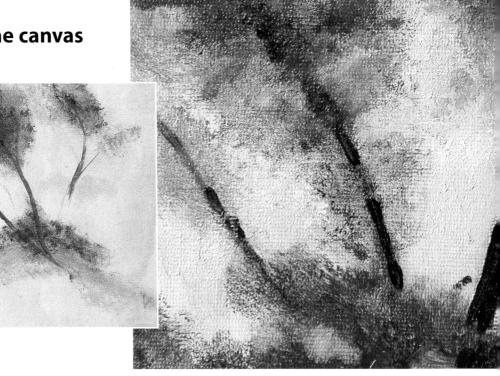

Dabbing onto canvas or canvas board leaves the troughs of the weave largely untouched. Some mixing of the paint and some optical mixing can be seen here.

Scumbling

Scumbling involves applying an uneven layer of paint over a dry, thin, relatively oil-free underpainting so that the first colour shows through. It can create very attractive effects, and is also an excellent way of modifying colour without sacrificing liveliness. The surface texture of the paint is more evocative than flat colour, and may well carry the illusion of its subject more effectively.

Dark colours can be scumbled over light ones, but the method is usually more successful with light used over dark. Thick, undiluted paint is often applied in a circular motion with either a well-loaded, round bristle brush held perpendicularly, or alternatively, a fairly wide, flat hog carrying thick paint can be dragged nearly flat to the surface, leaving a flecked broken layer of paint. Scumbles can also be applied with the fingers or a rag.

The coarser the texture of the canvas, the more effective the scumble, because the paint is deposited mainly on the top of the weave.

Scumbled clouds

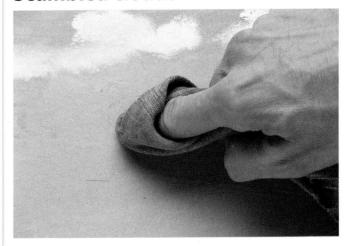

1 The sky was previously painted pale blue and allowed to dry. Clouds are now built up by scumbling with a rag, using a gentle rocking motion of the finger.

> **2** Scumbling with a brush leaves bristle marks between which the underlying layer is visible. The method allows soft merging of colour, with imperceptible gradations.

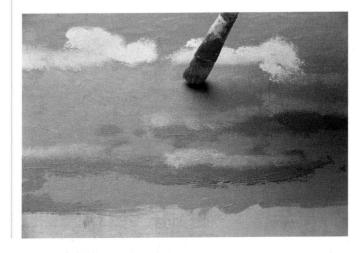

Scumbled texture

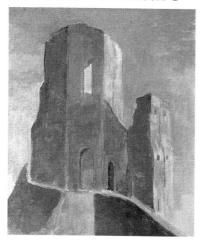

1 The artist has begun with a flat underpainting in acrylic, which dries very quickly. The dull greys will be modified and enriched in the following stages.

2 The brushstrokes are made short and decisive so that overblending does not spoil the effect.

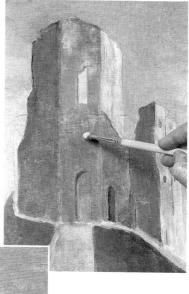

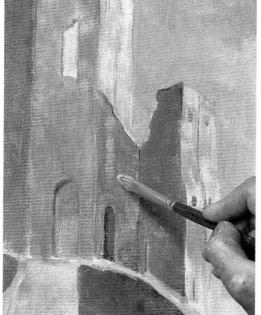

3 The weave of the canvas board is fairly coarse, so that the scumbled paint is deposited on the crests of the weave.

Tonking

A painting will often reach a stage when it becomes unworkable because there is too much paint on the surface. Any new colour simply mixes with that below, creating unpleasant muddy mixtures as well as disturbing previous brushwork. When this happens, the excess can be removed by 'tonking', a method named after Henry Tonks, a former professor of painting at the Slade School of Art in London. A sheet of absorbent paper such as newspaper or paper towel is placed over the overloaded area - or the whole painting – gently rubbed with the palm of the hand and then carefully peeled off. This takes off the top layer of paint, leaving a thinned-out version of the original, with softer outlines, which serves as an ideal underpainting over which to continue.

1 A common mistake is to build up the paint too thickly in the early stages. It is virtually impossible to continue working over such a thick layer, so the artist can either scrape off the paint (see page 84) or use the tonking method. The artist here decides on the latter course.

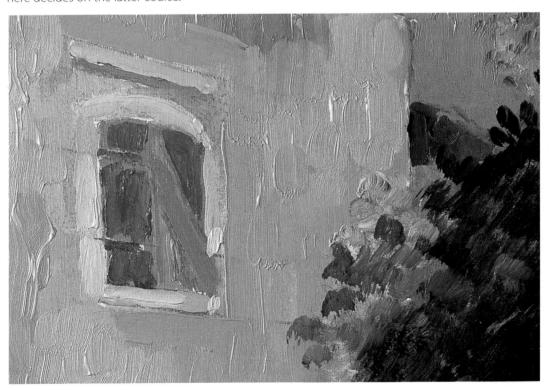

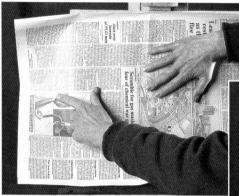

Newspaper is carefully laid over the part of the painting to be tonked and is rubbed firmly with the palm of the hand to make sure that the upper layers of paint adhere to it. The paper is slowly peeled off the painting, bringing the paint with it.

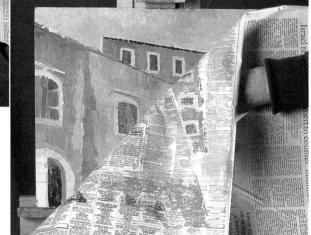

After tonking, only a thin layer of paint remains, with brushmarks smoothed away and details eliminated. This is an ideal surface for further working. Tonking can be performed as often as you like during the course of a painting.

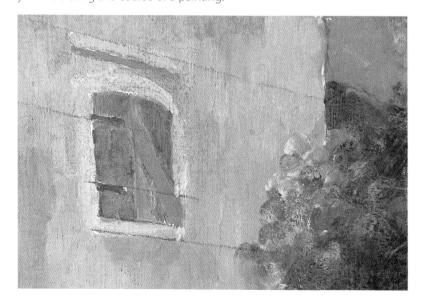

Scraping back

Removing paint from the canvas or board with the flat edge of a painting knife is not only a way of making corrections (see page 84); it is a valuable painting technique in its own right. Scraping off paint will leave a vaguely defined ghost image formed by the remaining thin layer of colour, so it follows that deliberate scraping back allows you to build a painting in a series of such layers without leaving brushmarks.

On canvas the knife removes most paint from the raised fibres, leaving that between the weave more or less untouched, while on a smooth panel scraping back produces a very flat, almost texture-free layer of paint.

The technique, which is ideal for misty effects, was quite unintentionally pioneered by James Whistler, who often scraped down his portraits at the end of a session, preferring to begin again rather than overworking. Having done this with a painting of a girl in a white dress, he suddenly found he had achieved just the gauzy, transparent look he wanted for the fine, delicate fabric.

1 This detail illustrates how the scraped paint is removed from the crests of the canvas weave but remains in the troughs. The scraping action sometimes gives a streaked effect, as here.

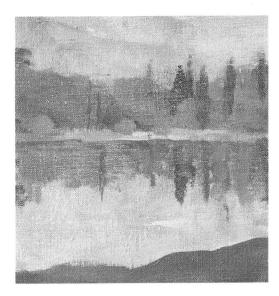

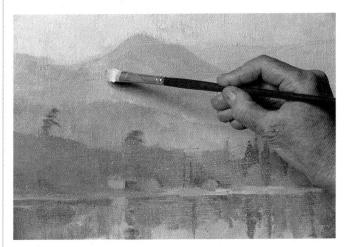

2 The paint has been scraped back once, and more paint of a different colour and tone is now added. This will eventually be scraped back to leave some of the old paint together with some of the new in a somewhat random manner.

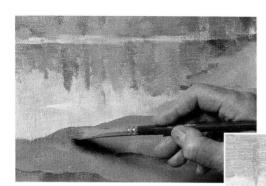

3 Layers of bluish and then greenish paint are being applied and then scraped down with a palette knife.

scraped again to enhance the misty effect. The horizontal streaking caused by this treatment mimics the way patches of mist tend to lie in motionless veils above still water.

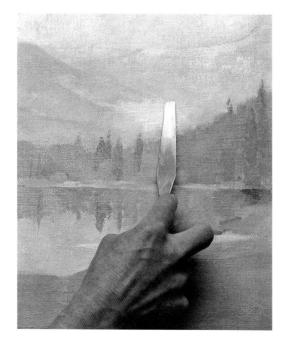

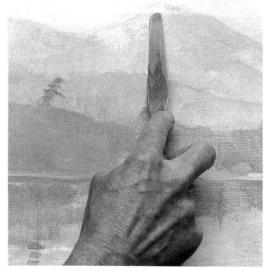

5 The pale paint added earlier to the mountainsides is now partly removed with the palette knife so that the thin covering of paint merges almost imperceptibly into the sky.

Sgraffito

This technique, whose name comes from an Italian word meaning to scratch, involves scoring into the paint with any rigid implement such as a paintbrush handle or a knitting needle to reveal either the ground colour or a layer of dry colour beneath. Lines of any thickness can be drawn into the paint and the separate layers of colour can be chosen to contrast with or complement each other. Dark brown paint, for example could be scored to reveal a pale blue, or a dark green to reveal a brighter, lighter one beneath.

The quality of line depends on the thickness of the paint and to what extent it has dried. Even thoroughly dry paint can be scratched into, as long as a really sharp point is used, but in this case the scored lines will be white, since all the layers of paint will be removed. For this method it is best to work on a rigid surface such as canvas board, because stretched canvas might be damaged.

1 The background colour of the wooden tabletop is applied in fairly thick paint. The pattern of the wood grain will be defined by scratching at a later stage to reveal the dark brown ground colour.

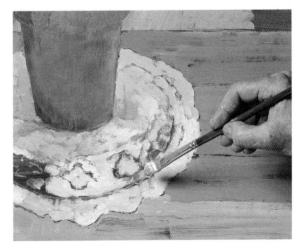

2 The doily is now painted with thick off-white paint, leaving small areas of the ground colour showing.

3 The artist uses the point of a painting knife to 'draw' in the pattern of the wood grain.

5 The complex pattern of the doily is drawn into the still-wet paint with a pencil. Like the paintbrush handle used earlier, this scrapes the paint aside, but it also leaves its own mark, the brown ground only showing in the regions where it was left unpainted.

Analysis Sgraffito

Rupert Shepherd The Lustre Jug

The overall effect of this painting relies heavily on the sgraffito technique, which has been used very skillfully to define contours and describe pattern on both the object and background. The latter is basically flat, but is enlivened by fine cross-hatching. In this case the paint has been scratched back to the white ground, which is best done when the paint is dry or semi-dry.

> Intricate pattern built up by scratching with a fine point to reveal the white ground.

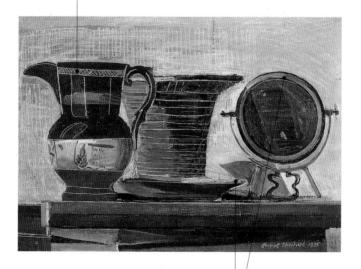

Sgraffito used to add definition to shapes.

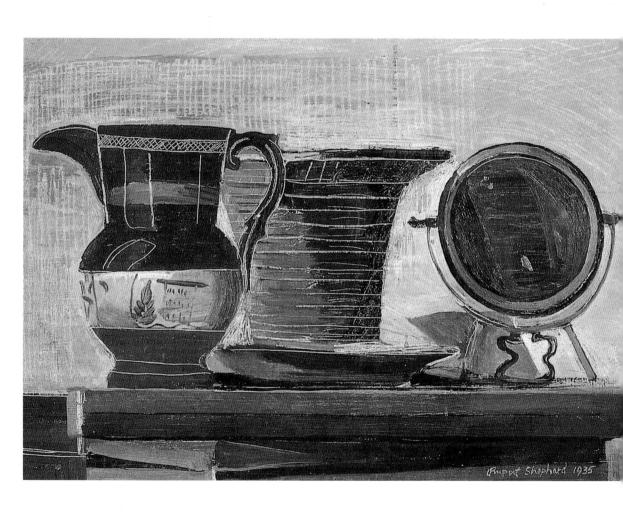

Texturing

Unless oil paint is very thinly applied, its very nature provides texture in a painting, but you can achieve more dramatic textures by mixing the paint with one of the special impasto or texturing mediums, which allow much thicker applications than normal and reduce the danger of shrinkage and cracking. Once on the support, the heavy paint mix can be sculpted and modelled, using any implement suitable for the job. Other favourite additives are clean sand, sawdust and wood shavings. Sand gives the paint surface a granular texture, while paint containing sawdust can be cut with a knife once it has partly dried. Wood shavings give a very obvious texture, which is best restricted to certain areas of a painting, where it could contrast with smoother ones. When using additives such as sand or sawdust, make sure that they are clean and will not contaminate the paint.

Sand and paint

The addition of sand to paint straight from the tube gives it a grainy, glittering texture.

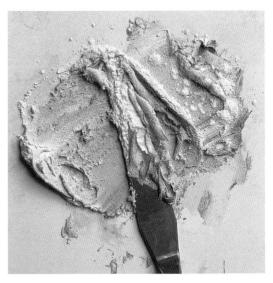

Plaster and paint

Plaster or decorator's filler also increases the paint's bulk and gives a fine-grained, cementlike texture when the paint is dry.

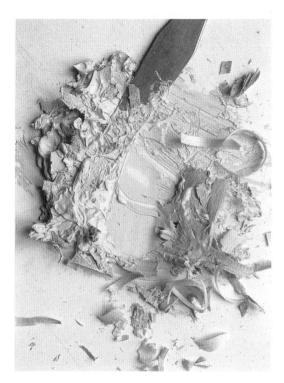

Wood chips

These chips give a very pleasing, flaky texture to paint, especially good for use in large paintings.

Sawdust

This increases the paint's bulk, enabling the application of very thick impasto. The resulting texture is slightly granular.

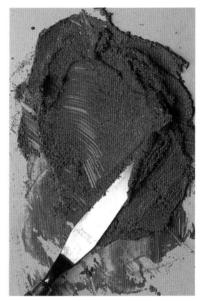

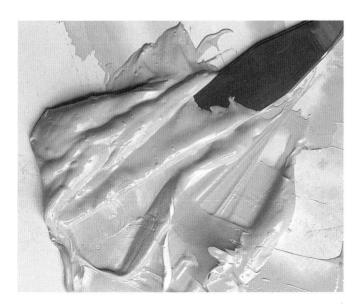

Commercial bulking mediums

Here the paint is mixed with impasto medium, which bulks it out without altering its colour or texture. The paint will become slightly darker as the medium dries out.

Underpainting

Not all artists begin their work with an underpainting, but it can play an important part in the more deliberate and considered type of painting, since the idea is to leave parts of it visible in the final painting to provide colour contrast, rather like a coloured ground (see page 80).

The colours to choose depend upon those to be applied later, but in general, cool colours will complement warmer final layers. The early Italian and Renaissance artists painted warm skin tones over green, blue or even purple underpainting. Creamy pink or yellowish flesh colours painted as glazes or thin scumbles over such colours acquire a rich, glowing appearance, while the cool greens of foliage are often more forceful if small touches of a warm brown or reddish undepainting are allowed to show through. The paint should be well thinned with turpentine or thinners (see page 22), and left to dry before overpainting. Alternatively, you could use fast-drying acrylics for the underpainting.

1 The board was first stained with yellow ochre (see page 24), and cobalt blue diluted with a large quantity of turpentine was used for the preliminary underpainting. In this case, it was not intended to play an important part in the finished painting, the main aim being to establish the dark and light passages within the intricate pattern of leaves, stalks and reflections.

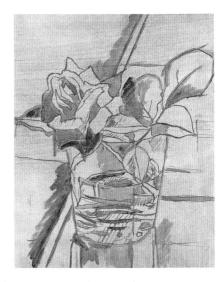

2 The dark background on the left has been blocked in with thin, lean paint, and the artist now works on the leaves.

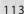

3 The painting has now reached a halfway stage, with the thinned paint now dry and ready to receive some of the final colours.

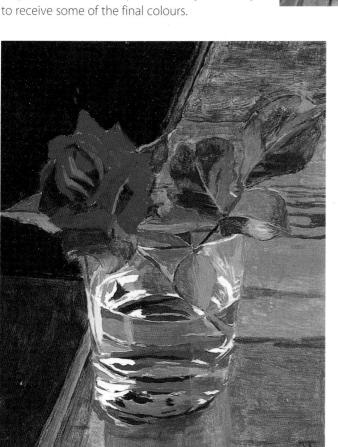

4 The underpainting has been very loosely handled, although care has been taken not to lose sight of the carefully measured-out drawing, particularly that of the glass - a difficult subject. Some of the final colours are now being applied.

5 In the finished picture, very little of the underpainting is visible, since great care has been taken to 'tidy up' the painting. The main benefit was to allow fluid brushstrokes that help to keep the picture alive. Small, intricate subjects like this can very easily become overworked and tired-looking.

Imprinting

Sometimes, you may find that the paint texture provided by brushes or painting knives falls short of your expressive needs, or you may simply want to experiment with other methods. The slow-drying nature of oil paint, together with its plasticity, enables it to be retextured on the canvas itself. This can be done by pressing a variety of materials or objects into it and then removing them to leave imprints. Almost anything can be used for this method. The most satisfactory marks tend to be left by objects with holes (slotted spoons), grooves (forks), serrated edges (saw blades) or any open structures. The thickness of the paint, the pressure you apply and other factors will affect the texture and quality of the imprint, so try out different effects.

This technique is perhaps most relevant to non-representational painting, but it has been used successfully by a number of contemporary artists to create exciting textures where the surface quality of the paint is of paramount importance.

Dabbing with foil

Here, green paint has been dabbed with crumpled foil so that a faint image of the yellow ground shows through. The streaks have been made by the sgraffito technique (see page 106).

Household implements

This pitted and veined pattern has been formed by pressing a teaspoon into wet paint and slightly twisting it.

Regular patterns

Thick pink paint mixed with impasto medium (see page 22) has been imprinted with the base of a film canister. Here and there the pink paint has come away to reveal the red ground beneath.

Combined methods

The ribbed texture was made by the blot-off method, a similar principle to imprinting. In this case, a piece of nonabsorbent paper was placed on wet paint and then pulled away. The brick design is the imprint of the end of a matchbox.

Revealing underlying colour

This pattern was made with a fork, which has removed the upper layer of dark paint to reveal the red under-layer.

Masking

This simply means covering up parts of the picture surface with cardboard or tape so that they remain untouched by paint being applied to adjacent areas. The use of masking tape is invaluable for any paintings that rely on hardedged, ultra-straight boundaries between colours and tones, while cut-out pieces of card or adhesive film can be used to achieve crisp, curved contours. Masking is not recommended for the freer, more impressionistic type of painting, since such hard edges would look incongruous.

The mask must be applied to virgin canvas or a thoroughly dry, thin underpainting, and the paint should be fairly thick to prevent it running underneath the mask. It should be left to become dry or at least semi-dry before the mask is removed. If the adhesive has hardened, as it may after a period of time, it can usually be dissolved with lighter fluid or thinner.

1 This artist likes a crisp, sharp-edged effect and uses his paint guite thinly. He began by making a careful drawing with a pencil and ruler and then placed masking tape over all the edges.

2 Paint thinned with an oil and turpentine mixture was applied quite freely over the tape.

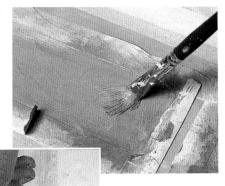

3 The paint was allowed to dry, and the tape was lifted, giving clean, precise edges.

4 The dark paint for the floor area was applied in the same way.

5 The area around the broom is to be spattered, so the rest of the painting is protected with newspaper and more masking tape.

6 The effect of the spattering can be seen in the finished painting, contrasting with the clean straight edges.

Monoprinting

This is a fascinating and enjoyable technique that is a kind of cross between painting and printmaking. There are two basic methods. In the first, a painting is done on a sheet of glass or other non-absorbent surface, and a piece of paper is laid over it and gently rubbed with a roller, or simply your hand. The paper is then carefully removed, and you will see a 'printed' version of the original painting.

This can be left just as it is, if satisfactory, or allowed to dry and then another medium, such as pastel, can be worked into it. Monoprinting is essentially a mixed-media technique, and both chalk and oil pastels combine well with paint.

The second method involves covering the whole of the glass slab with an even layer of paint, placing the paper on top and drawing on the back (top) of the paper. The drawn lines will print, but take care to let the paint dry slightly before drawing or it will simply come off all over the paper.

You can achieve a wide range of different effects in this way, varying the kind of line you use, and creating textures by pressing objects onto the paper. You can also print in two or more colours, simply by inking up the glass with a different colour for each printing.

Painting on glass

One of the beauties of the monoprinting technique is that so many different effects can be achieved. All the pictures shown here are by the same artist, Ingunn Harkett, but they each show a different use of the method. In Figure 1, the image was painted on a glass slab with a thick but not oily paint (too much oil makes it difficult to control) and a print was taken by simply rubbing with the hand.

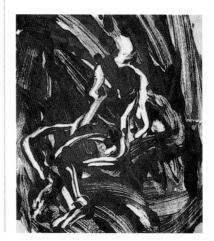

Drawing into paint

A similar method was used for Figure 2, with the white outlines of the figure achieved by drawing into the paint with a piece of card - any tool that comes to hand can be used.

Multiple printing

Seated Nude is a more elaborate picture, the result of several stages of printing, with further colours and textures added to the original painting on glass each time. This creates intriguing effects, since the paint builds up on the glass to give different textures to the print. The white lines were again produced by drawing into the paint, in this case with a brush handle.

Colouring the paper

As before, Still Life in Spring was painted on glass and then printed, but the printing paper itself was given a thin coat of pink and blue acrylic first. Firm pressure was applied with a hand roller, since a clear image was needed. The print was then worked into with more oil paint to add an extra dimension of texture and brushwork.

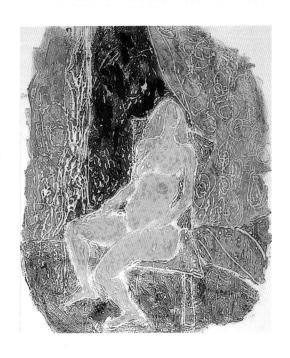

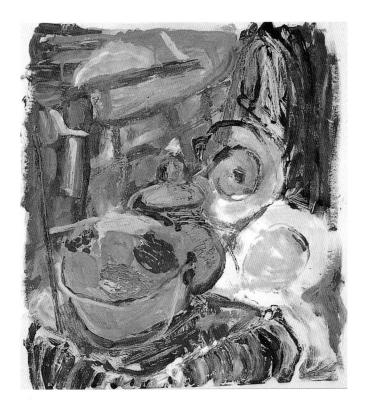

Mixed media

This term is most often found in the context of 'works on paper', which may be mixtures of watercolour with gouache, pastel, pencils, wax crayons and so on, but other media can also be used in combination with oil paints. It can be very liberating not to be bound by one medium, and is sometimes a way to save a less than successful painting.

Oily pigments can be applied over water-based ones, so an underpainting in watercolour, gouache or particularly acrylic forms a good base for overpainting in oil, which is one way of mixing media.

You cannot paint with acrylic over oil, but oil, once dry, can be worked over with both soft pastel and oil pastel, and drawn into and over with pencils. Such techniques can produce intriguing broken textures, rather like dry brush and scumbling methods (see pages 74 and 100), and also provide a means of sharpening up and redefining edges and small details.

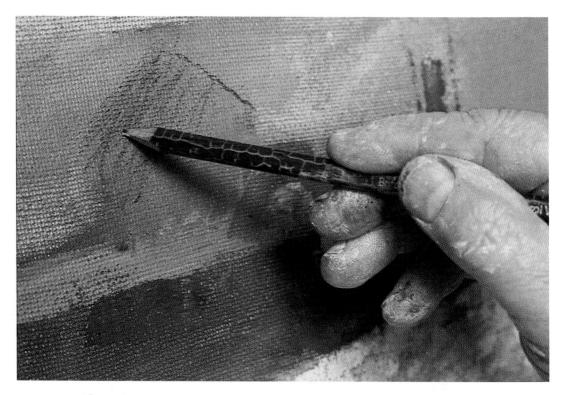

1 Pencil combines well with oil paint as long as the latter is not too thickly applied, and here the artist is drawing over the paint to redefine forms and to provide a variety of textures. Much of the pencilling will remain visible in the final picture.

2 Oil pastel can be dabbed and stippled over oil paint, and in this case is ideal for describing the dancing light on the water.

3 The graphic quality of the pencil, the heavy texture of the canvas, the large swathes of oil paint and the dabs of oil pastel complement one another beautifully. It is worth mentioning that this exciting painting was derived from a rather dull photograph; the inventive use of media minimizes the temptation of direct copying and encourages a personal means of expression.

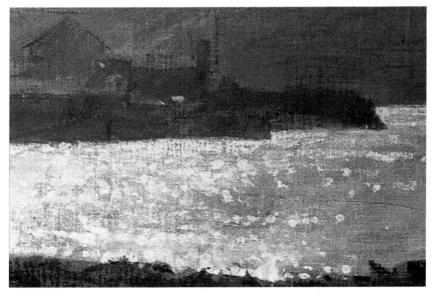

Materials

Hard or soft brushes

To apply paint to large areas, or to apply very thick paint, bristle brushes are best. For a smooth surface or for fine details, and for applying thin paint such as glazes, soft brushes such as sable should be used.

Sable or synthetic

Sable brushes are the best-quality soft brushes, but cheaper alternatives are available in the form of sable/synthetic mixtures and synthetic brushes. These lack the springiness of sables, and may lose their shapes more guickly, so if you use soft brushes a lot they may be a false economy in the long run.

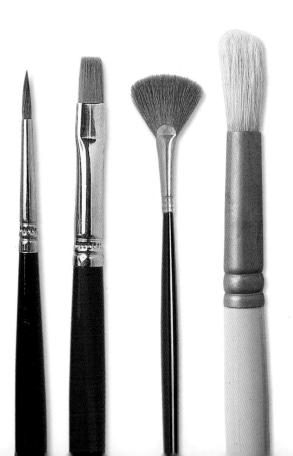

Cleaning brushes

To get all the paint out of a brush, first rinse it in white spirit to remove as much as possible. Then, draw the brush across the top of a bar of soap under running water, with the bristles horizontal to the surface of the soap. Repeat this a few times, working the soap through the bristles and drawing paint out of the ferrule. When no more paint comes out, rinse in clean water.

Palette alternative

There are several alternatives to wooden artists' palettes that are both cheaper and available in larger sizes. A sheet of glass laid over a sheet of white, neutral or medium-toned paper is one possibility for studio work. Apply masking tape along each

ARTIST'S TIP

White spirit that has been used for cleaning brushes needn't be thrown away. Cut the top from a large plastic bottle or use a large glass jar and leave dirty spirits to stand until the paint has sunk to the bottom. The remaining spirit may be discoloured, but can be used again, so pour it into a clean container and store for re-use.

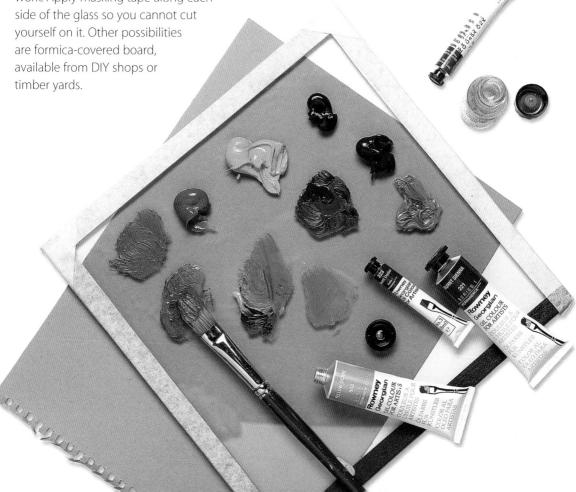

Colour

Darks without black

Mix 'coloured blacks' rather than using tube black: ultramarine and burnt sienna, or alizarin and viridian make good vibrant darks. and ultramarine and cadmium red dark produces a colour that is almost black but is capable of subtle modulations of warmth and coolness.

Ultramarine + Cadmium red

Alizarin + Viridian

Ultramarine + Burnt sienna

Darkening tones

Black added to colours to darken them can produce dull, dirty-looking results, though black and yellow do make a good green. Instead, try mixing in a darker version of the same or a similar colour, or mix in a little of the colour's complementary colour for a darker, but slightly greyed version. The complementary pairs of colours are red and green, blue and orange, and violet and yellow.

Red + black

Red + dark red

Red + green

Yellow + black

Yellow + Yellow ochre

Yellow + violet

Darkening colours

To darken a colour that has already been applied to the canvas, let it dry, and then glaze its complementary colour over the top.

Cadmium red + Phthalo green

Dioxazine purple + Lemon yellow

Cleaner colours

If your colours look muddy on the canvas, it could be that you've mixed too many colours together. For fresh, lively colours, mix the minimum number – preferably two or three. Also, keep cleaning your brush as you work, since unwanted colours creep into a mix from a dirty brush.

Muddy

Cadmium red Cobalt blue Payne's grey Yellow ochre

Chrome yellow Yellow ochre Cerulean blue Cobalt blue

Cadmium red Alizarin crimson Chrome orange Cobalt blue

Bright

Cadmium red Cobalt blue

Chrome yellow Cerulean blue

Cadmium red Chrome orange

Pointillism

If you have tried the pointillist technique and the colours don't seem to be mixing, it could be because they vary too much in tonal value. To work effectively, the colours used should be close in tone, so you may need to add white to colours that are naturally dark. Use dryish paint, and apply it in short strokes, making sure that the brushstrokes don't blend together.

Colour

Enlivening dullness

If there are dull, flat areas in a painting, try scumbling another colour, such as the complementary hue, over the top. Adjusting other colours nearby or introducing tiny touches of a bright shade may also do the trick.

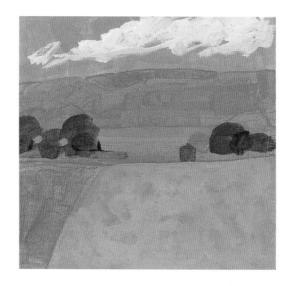

Bright yellow scumbled over the foreground field and added into the trees brightens up these areas and introduces a feeling of light into the scene.

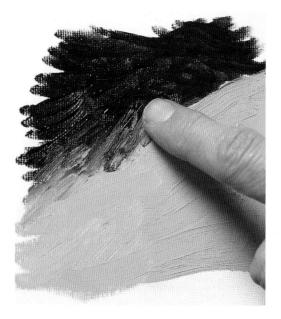

The yellow is toned down by blending it around the edges with the colour next to it.

Over-bright areas

Areas of colour that are too strong can be knocked back by blending the edges with the colour next to it, or by knocking it back with a finger. Alternatively, the colour can be modified by scumbling or glazing another one over it.

A smooth gradation

To get an absolutely smooth, barely perceptible gradation from one tone or colour to another, prepare a colour mixture for each. Apply the colours separately, the darkest one first and the lighter one next to it, then blend first with a bristle brush and then with a fan brush, using short strokes and working across the edge between the two areas of paint.

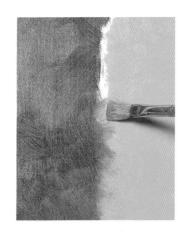

Two colours are laid down and then pulled into each other.

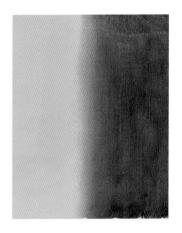

The colours have been blended together until a smooth gradation is achieved.

Rough blending

Apply two tones or colours next to each other, and knit them together with short zigzag strokes to create a broken edge.

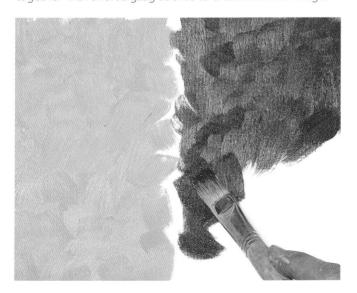

Two areas of colour are laid next to each other.

ARTIST'S TIP

Sometimes areas of colour appear to 'sink'. This can be cured either by 'oiling out' – rubbing a little linseed oil sparingly over the area in question with a soft cloth and leaving it for 24 hours – or by giving it a thin coat of retouching varnish using a soft brush and leaving it to dry, which takes up to about 15 minutes.

Painting surfaces

Rolling a canvas

Canvases shouldn't be rolled unless it is unavoidable, because it can cause cracks in the sizing and paint layers. If a canvas has to be taken off the stretcher and rolled, for storage or carrying, roll it around a cylinder with as wide a diameter as possible, and roll it with the paint surface facing out. This way, when the canvas is unrolled, any cracks will close up again.

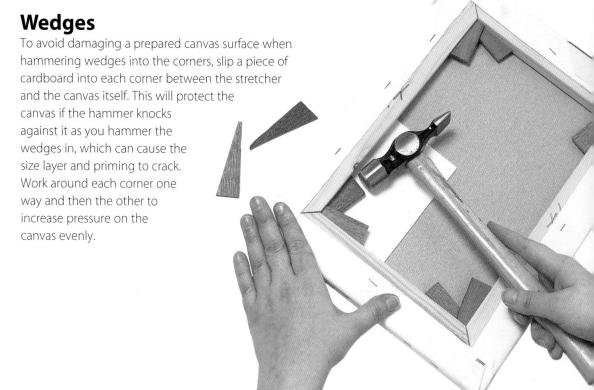

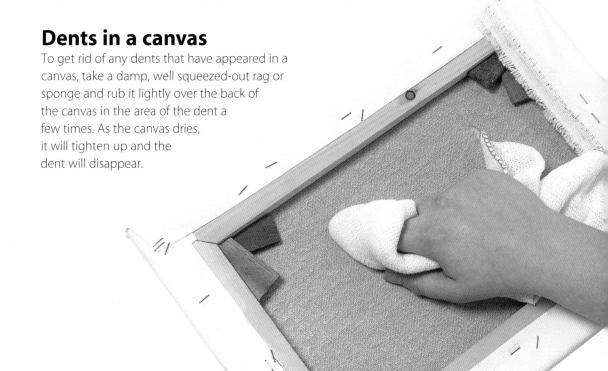

Re-using supports

It is better not to re-use canvas or boards unless the paint is still wet and can be scraped off. The new paint may not adhere properly to the surface, and the texture of the original painting may interfere with the new one. However, you can make a more usable surface by sanding the surface as long as the old painting is completely dry. It can then be re-primed with an oilbased primer.

ARTIST'S TIP

Irritating lines can appear near the sides of a canvas, caused by pressure against the stretcher bars behind. This can happen if you do lots of rubbing and scraping off, but can be prevented by inserting strips of thin foam or bubble-wrap between the stretcher bars and the canvas to cushion the canvas if it is pressed against the edge of the bars while you are working.

On location

Paint boxes

A convenient type of paint box for working on location is a readymade one that combines palette and paint box in one and holds painting boards in the lid. These are available in a choice of sizes. The smaller sizes can be held in one hand, while leaving the other free to paint, or they can be rested on a wall or on the knees if you are sitting.

Paint and mediums fit into one division, and brushes into another

The boxes are designed for standard-sized tubes of paint, though a large tube of white will usually fit in.

The painting board is held in the lid. Make sure you clean the palette or turn the picture around before replacing the lid.

Carrying handles are usually made of leather, though some may be plastic.

The palette fits in above the compartments for paints and brushes. Once you have laid out your colours you can slide the palette back into place for mixing.

Limited palette

When you are working fast or in difficult conditions, it helps to limit the number of colours that you use. You will need one each of the primary colours; red, yellow and blue (see page 28), plus white. Lemon yellow, burnt sienna and cobalt blue give a selection of fresh colours: yellow ochre, cadmium red and cerulean blue give a choice of bright or subtle colours.

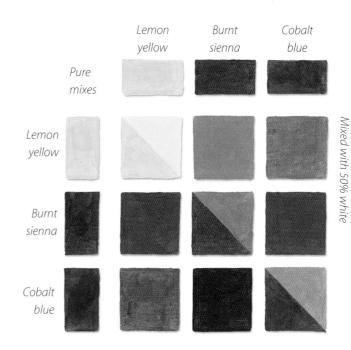

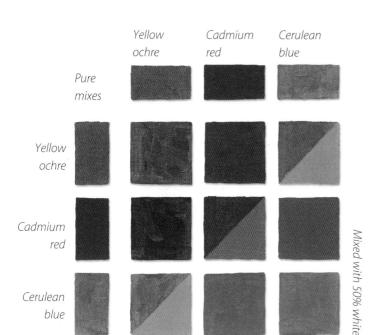

Very limited palettes can provide a good choice of colours to work with. They can be mixed to produce a range of interesting greys and browns, darkened through the mixing of complementaries, and made lighter and more opaque with the addition of white.

On location

Short-term subjects

Some subjects, especially those involving people, are only there for a short time. To retain the immediacy of working directly from life, make a pencil drawing of the scene on the spot on stretched watercolour paper, recording all the information you want to include in the painting. Additional colour notes will be useful. When you get home, give the paper a coat of shellac varnish or acrylic medium, which will seal the surface without concealing the drawing, and when this is dry, apply the paint, working fast over the drawing to complete it in one session.

Two palettes

Two small palettes are easier to manage than one large one on outdoor painting trips if you need plenty of space for mixing colours. A small palette is easier to hold in difficult weather conditions, and smaller sizes are easier to pack away for carrying.

ARTIST'S TIP

Even quite a mild breeze can catch a large board or canvas on a sketching easel and blow it over. To prevent this from happening, suspend a bag filled with something heavy such as stones (you may be able to collect them on the spot) from the centre of the easel to weigh it down. Another method is to use two pieces of clothesline attached to tent pegs.

On location

Carrying wet canvas

To carry a wet canvas or board, you will need a second one of roughly the same size, plus four small pieces of cork about 2.5cm (1 in) thick, and some masking tape. Lay the painting flat and place a piece of cork in each corner. Place the second board or canvas on top, and tape the corners together. The painted surfaces are held apart, but face inwards and thus protect each other. If the corks leave a mark, the corners can be touched up again at home.

ARTIST'S TIP

When you have a limited time in which to complete a painting, the best approach is to break down the subject into simple overall shapes and block these in with thinned-down paint. At this stage don't mix more than two colours together and don't add white. Control the tones through the thinness of the paint, and wipe back any areas that are too dark. This will give you a clear foundation on which to build the painting.

Speeding up drying time

Quick-drying alkyd gel medium (see page 23) will speed up the drying time of the paint. It is available in tubes as well as bottles, and can be squeezed out on the palette. Add a little to the paint that you mix for blocking in the composition to prevent subsequent layers picking up colour from the first layer.

Landscape Summer

The most noticeable thing about summer landscapes in some climates is their lush greenness. But while lovely to look at, this very quality can become monotonous in a painting unless the colours and tones are carefully controlled.

Greens vary widely; some are almost yellow, some have a distinct bluish cast, while others - such as the dark olive greens - can seem nearer to brown than green. There are also many other colours among the greens – from pale yellow highlights to blue, violet or brown shadows - so always try to make the most of these rather than painting everything in darker or lighter versions of the same colour.

An excellent way of matching colours is to make a mixture on the palette, load the brush with it and hold it up to the subject. This allows you to see immediately whether a colour is too dark, too light, or the wrong shade of blue, green or yellow.

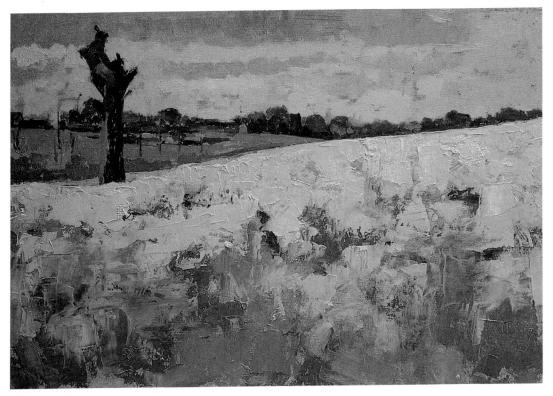

Balancing colours

In James Horton's Rape Field the bright yellow flowering rape and the fully foliaged distant trees instantly suggest early summer, albeit on a dull and overcast day. Although the yellow field covers two-thirds of the picture surface, the artist has prevented the colour from becoming overbearing by balancing it with strong greens in the foreground. The texture of the field has been achieved by knife painting (see page 92).

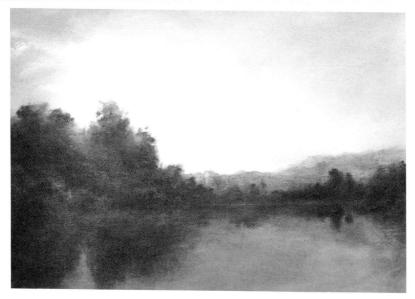

Summer earth tones

The strength of Paul Kenny's *The Wooded Lake at Fontainbleau* lies in the complementary relationship between the area of subdued red-brown on one side and the area of muted green opposite. This, along with the yellowish hills and the blue sky, offers a full breadth to the colour scheme.

Complementary contrast

The relaxed and happy atmosphere of a summer day is beautifully recreated by the lush greens and dense foliage in David Curtis's *The Ice Cream Seller*. The painting is almost entirely composed in vivid greens and muted blues, with the one touch of brilliant orange providing a complementary contrast to the greens and drawing the eye into the centre.

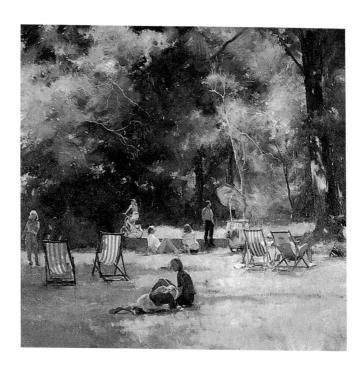

Landscape Winter

Many of the sensations typical of winter are felt rather than seen, but a good painting can evoke physical sensations, often by providing visual clues, such as a pale, weak sun, lowlevel clouds, stark bare trees or figures leaning into the wind with their clothing clutched around them.

You can also suggest cold by means of colour. The colours of winter are in general more subdued than those of summer, and less warm. One of the dangers is that a painting in which cool greys and blues predominate can become dull, so it may be necessary to include accents of bright, warm colour for contrast. The whiteness of snow, for instance, can be highlighted by the inclusion of a red roof or a figure in bright clothing. In fact snow, although appearing white at first glance, often contains a host of blues, violets and greys, or it reflects colour from the sky.

Colour accents

► The cold, icy blues in Arthur Maderson's Approaching Dawn, Mendips are tempered by accents of warm reds, yellows and ochres scattered through the painting. Although no white has been used, we have no difficulty reading this as a snow scene.

Weather effects

Damp, frost, mist and a low sun are the ingredients of this convincingly wintry scene. Brian Bennett's Peover Eye, Christmas Morning makes us feel the weather through a highly skillful use of tones and colours.

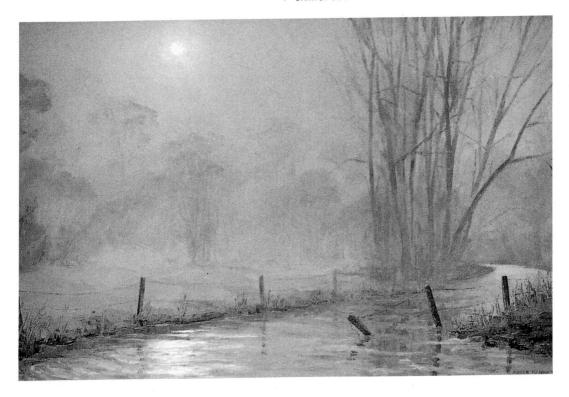

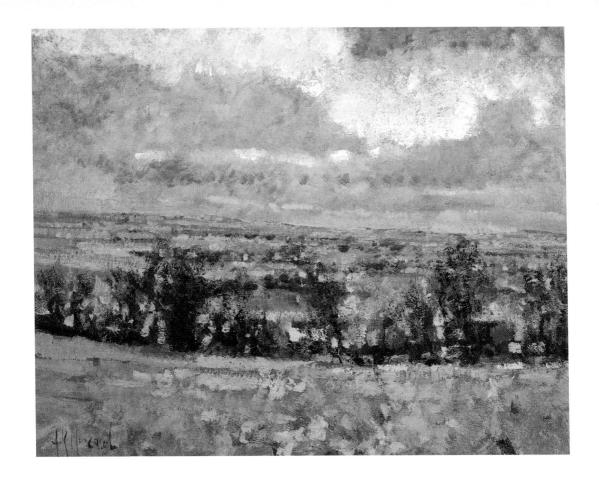

Warm and cool colours

In *The Edge of the Village* by Raymond Leech, the colours and tones are well-balanced in terms of both cool and warm tones and light and dark areas, in spite of the large expanse of snow. The ochres of the hay and the red browns of the trees and houses counterpoint the cool whites and blues of the snow and distant hills.

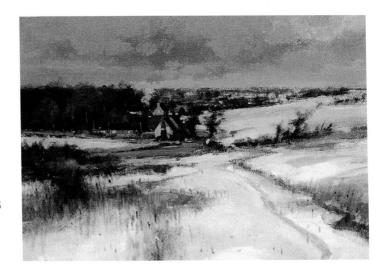

Landscape Water

Water is one of the most attractive of all painting subjects, but it does pose a challenge to the artist. It is transparent and yet has its own physical presence; it seems to reflect light in unpredictable ways; its patterns and colours are difficult to analyse. The first thing to realize is that you will have to observe very closely so that you can learn to simplify.

This applies especially to moving water, but if you watch a stream, waterfall or seascape for a time you will see that the movements follow a definite pattern, which is repeated again and again. Once you understand this, you will be able to paint with confidence, letting your brushwork describe the movement.

On the face of it, painting a flat expanse of water seems easier, but there is a possible pitfall. In beginner's paintings, water often appears to be flowing uphill, while in fact, of course, it is a flat horizontal plane and must be shown as such. If you paint it the same all over it will look like a wall, so you will have to find a way of suggesting recession. Putting in a few ripples or floating matter in the foreground is one way of doing this, and varying your brushstrokes so that they are smaller in the distance is another.

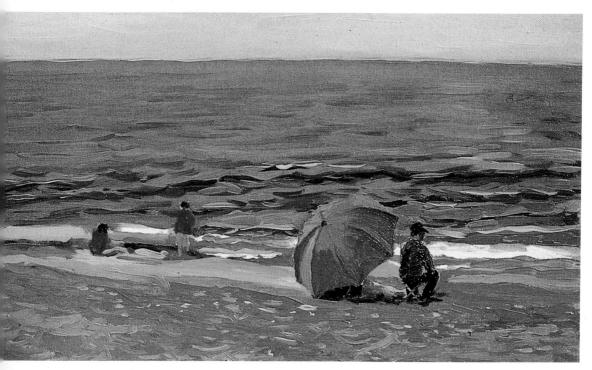

Perspective through brushwork

In Jeremy Galton's *Fisherman and Children, Cley-next-the-Sea* the recession of the horizontal surface is suggested not only by the paler tones of the more distant areas of sea but also by the larger brushstrokes in the foreground. The green umbrella and red-clad figures provide both atmosphere and foreground interest, enhancing the cold grey of the sea.

Reflections

The gently meandering river that forms the subject of Trevor Chamberlain's Mellow Autumn, River Beane is beautifully captured with an economic use of paint. The water owes its appearance partly to the reflections – the exact vertical mirroring of the trees ensures that it is read as a horizontal surface – and partly to the occasional ripples that describe its fluidity.

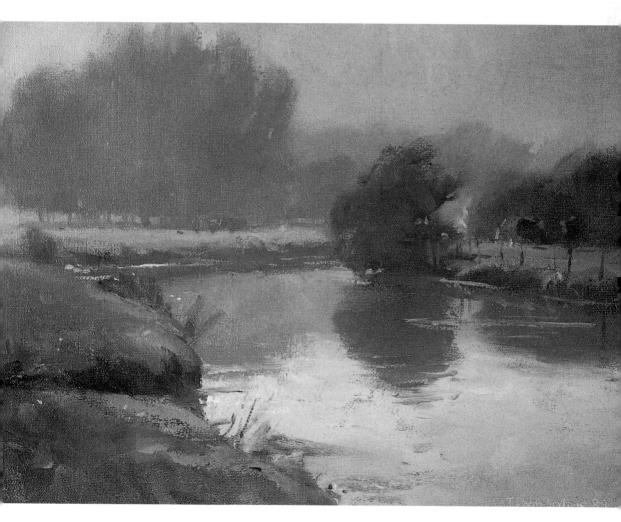

Landscape Moving water

Waves, fast-running streams and waterfalls are less easy to paint than still lakes and calm seas, but this is partly due to a failure to understand the behaviour of water. The shapes made by ripples as they swirl around an obstruction, or waves as they swell, peak and finally curl over into themselves do follow a certain pattern, so it is always worth sitting and watching before you begin the painting.

Another problem is deciding how you are going to catch this feeling of ever-changing movement. No one technique is more suitable than another, but a good general rule is to let your brushwork describe the flow of water, using directional strokes to follow its sweeps and swirls. Glazing (see page 86) can help to suggest the transparency of water as it flows smoothly over stones or sand, while wet-in-wet (see page 82) will produce blurred edges that might be ideal for waves.

Calm seas

In Pink Sails, France, Andrew Macara has used an impasto technique to capture the shapes and crests of the waves. The directional brushwork conveys the swell of the sea, and the water seems crystallized by the glancing light.

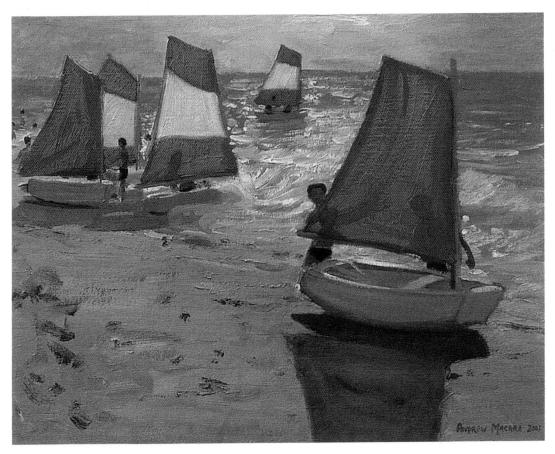

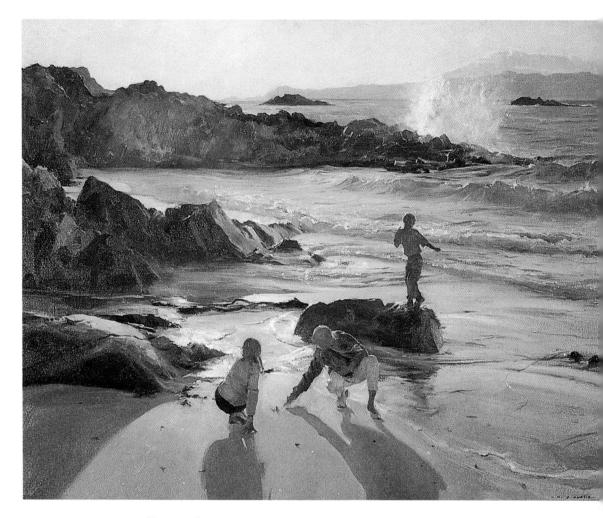

Leading the eye

In David Curtis's Evening Light, Arisaig the movement of the waves has been wonderfully well observed and depicted with great clarity, as has the shining expanse of shallow water on the sand. Notice also how the foreground shadows lead the eye in to the figures and then to the rocks and plume of spray, which forms a secondary but vital focal point in the composition.

Landscape Skies

Sky is nearly always an element in landscape, and sometimes can be the main subject of the painting, occupying a large part of the picture space. Skies and clouds are not especially difficult to paint in technical terms, but they do present a practical problem - clouds are always on the move, and if you are working on location you may not have much time to capture an effect. It is thus best to start with the sky, blocking it in rapidly and resisting the temptation to change it every time a better cloud formation appears. You can, of course, work from photographs, but because these can't capture movement they can make clouds appear very solid and static, so make sure you use your brushwork to give a sense of movement, and don't try to include every tiny detail and nuance of colour and tone.

Anchoring the sky

Skies are often so exciting that it is tempting to paint nothing else, leaving out the land or sea altogether, but this doesn't work as the airy expanse needs to be anchored to and juxtaposed by a contrasting element. In Paul Kenny's Giverny III, the still water plays a vital role in stressing the drama of the burning sky, while the cooler tones of the lily pond balance the fiery hues above.

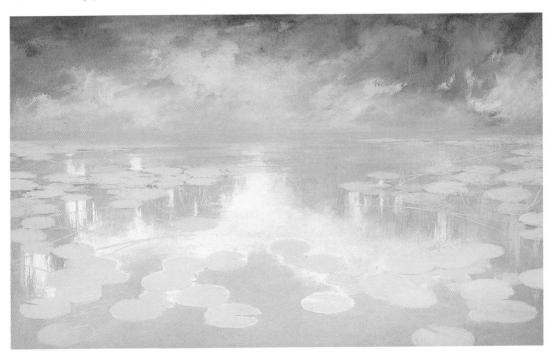

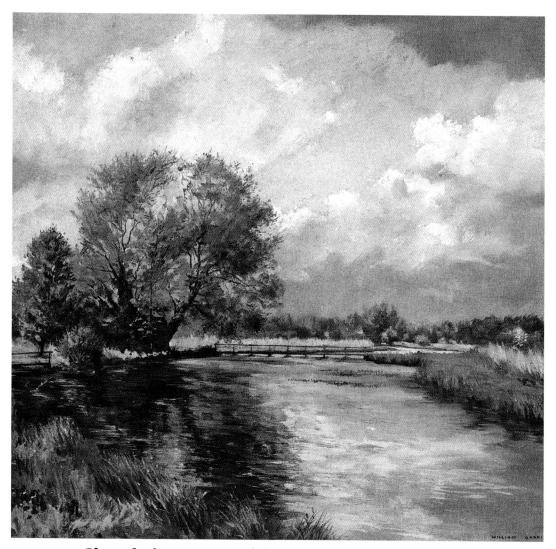

Clouds in composition

Clouds are shapes like any other landscape element, and play an important role in composition. In William Garfit's River Test at Leckford the clouds and their reflections occupy a large part of the picture space, and the artist has used these two sets of opposing diagonals to create an exciting composition with a strong feeling of movement. Notice also how he has brought in a dark cloud at top right to balance the dark tones of the tree and reflection.

Landscape **Trees**

Trees, particularly in the foreground of a painting, are a tricky subject to paint, mainly because of the difficulty of deciding how much to include.

It is always necessary to simplify to some extent, whether you are painting bare winter trees or foliage-clad summer ones. Far-off trees are less confusing simply because distance has done the simplification for you. Foliage and clusters of twigs appear as large masses, while closer up they divide into a bewildering number of smaller components, including individual leaves.

It is a good idea to make an initial assessment of the subject by half closing your eyes to blur your vision. This will throw the details out of focus and help you to establish the main shapes and colours of the subject.

Begin by blocking these in loosely with well-thinned paint. This will dry fast and act as an underpainting, over which you can begin to develop the smaller branches or clumps of foliage. Leave the fine detail until last, and make sure your brushwork is consistent with that of the rest of the painting.

Detail and generalisation

Through the Trees is an attempt to capture the hypnotic nature of trees in a pine forest. The artist, Brian Gorst, has taken care to vary the intervals between the trees and to retain their fractional tilts so as to avoid oversimplification.

Winter trees

The great variety of colours to be seen in winter trees is shown beautifully in David Curtis's Early Spring, Cordwell Valley, with pinks, browns and purples juxtaposed to give a gentle but subtly varied colour scheme. Just a few trunks and branches have been picked out in detail, leaving the rest as suggestions.

Varying the greens

The types of trees that can tolerate hot climates are often distinctly blue in colour, and James Horton has exaggerated this in his painting Avila to produce a composition with an overall blue bias. However, he has brought olive green and green-browns to contrast with the bluer greens of the foliage, while the orange-browns of the roofs and field give a feeling of warmth to suggest the hot climate.

Landscape Shadows

Shadows can play an important role in composition; a well-placed shadow can be used to balance other shapes, indeed shadows are often more visually exciting than the object that casts the shadow.

The colours of shadows are often misunderstood by beginners. They tend to be bluish or violet, and the reason for this is quite simple. A shadow is caused by an obstacle that prevents sunlight from striking the area, but a shadow is not an absence of light; it is still illuminated by the sky. Since the sun is shining, the latter will be blue, and the shadow will reflect this colour to some extent.

Another factor involved in our perception of shadows is vision itself. If you look at something yellow and then shut your eyes, you will 'see' an after-image of the complementary colour (in this case violet). Thus, when you look from a light-struck area to a shadowed one, the after-image becomes apparent in the same way.

Composing with shadows

Little sky is visible in Trevor Chamberlain's Spring Day, Chapmore End, but the strong shadows across the road leave the viewer in no doubt that this was painted on a sunny day. Their deep blues, browns and purples contrast strikingly with the pinkish browns, and their horizontal arrangement, at right angles to the vertical figure, fence posts and distant trees, establishes a firm geometric foundation for the picture.

Complementary colours

In James Horton's Landscape near Perpignan, the striking mauve-blue shadows echo the colour of the distant mountains, and in order to bring in complementary contrast he has heightened the yellows of the pathways. The shadows bring an exciting patterned element and also describe the contours of the ground, curving down from slightly higher ground on the left of the picture.

Tutorial Landscape

James Horton devotes considerable time to painting landscapes on location, mainly in oils. He will walk for miles with his travelling easel, paint box and stool, mentally noting possible viewpoints until settling upon his final choice for that session. In this studio demonstration, he reconstructs a painting he did in the French Pyrenees, adopting as far as possible the same procedure followed in the original.

1 The artist nearly always works on a coloured ground, leaving small areas uncovered in the completed picture. The composition has been marked out in diluted paint.

2 The first stages of painting involve an exploration of the chosen landscape in terms of colour and tone. Dabs of colour are placed all over the canvas to begin the process of relating one area to another.

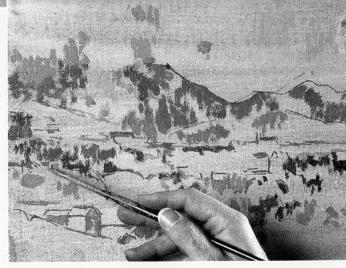

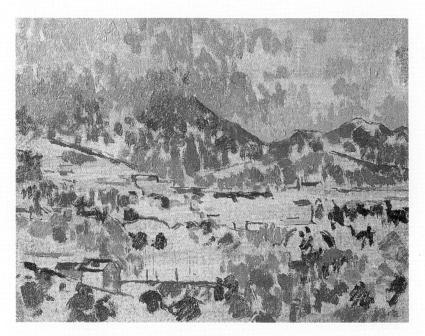

3 The relationship between the sky and mountains is established early on, since mistakes may be difficult to rectify later. The painting is to be completed in one session, and the marks now being made are likely to remain visible to the end.

4 In this detail, we see how the individual brushmarks are either pushed into one another by working wet-in-wet or remain slightly separate from their neighbours, thus leaving patches of bare ground showing.

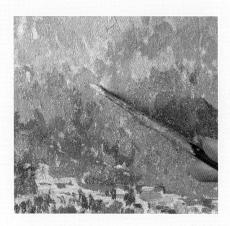

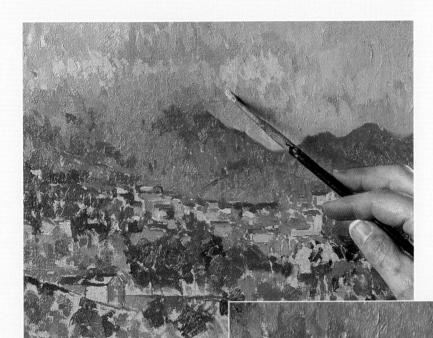

5 When working on location, the sky must be recorded early on, since weather conditions are liable to alter rapidly. The cloud around the mountain-top was a feature the artist particularly wanted to capture, and here is adding pale clouds wet-in-wet over darker regions of sky.

6 The detail shows the large amount of ground left bare in the early stages so that later additions or modifications of colour can be slipped into the gaps. This eliminates the danger of overworking the area with paint.

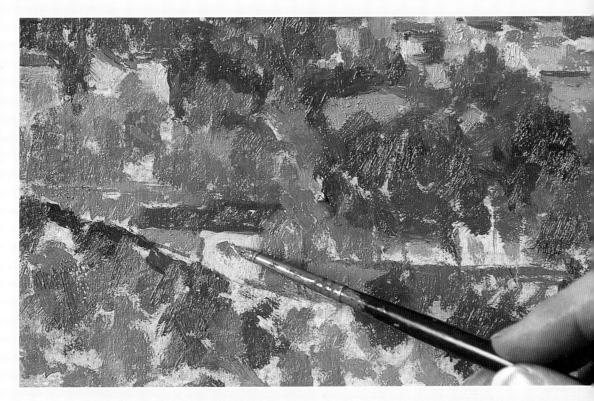

7 Details are added, with particular care being taken with the placing of roofs, windows and other architectural features.

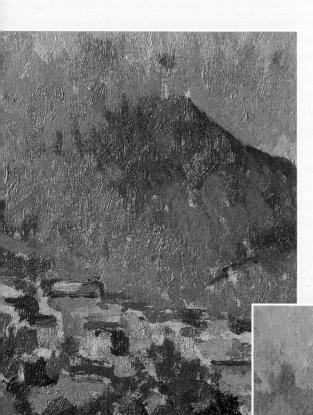

8 The whole composition is based on the interplay of warm and cool colours. In this detail, we see the richly coloured red and ochre rooftops, which provide a focal point of warm tints to which our eye is immediately attracted.

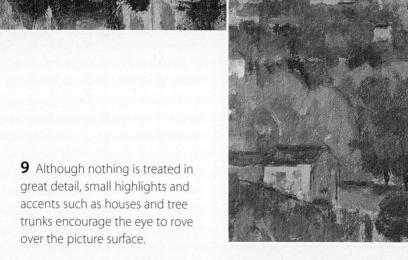

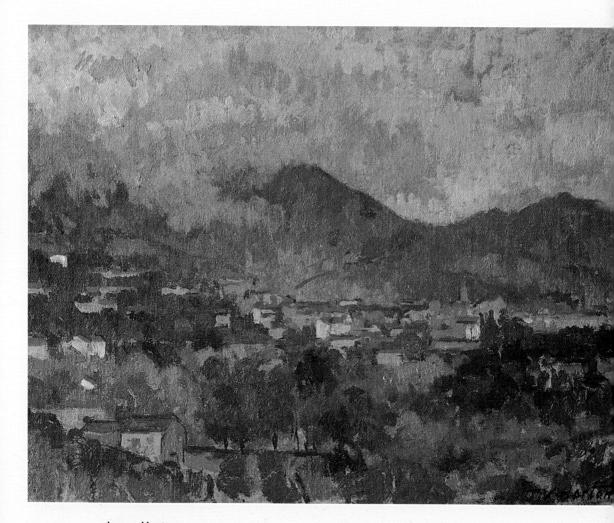

James Horton

St Laurent de Cerdan

The painting shimmers with light and colour, demonstrating the effectiveness of the artist's method of building up a network of small brushmarks and continually assessing one area against another.

Buildings Viewpoint

The main consideration in your choice of viewpoint is composition. Even slight changes in our own position can cause dramatic ones in the view in front of you, so be careful to explore all available possibilities. A good composition is a well-balanced one, and if you have chosen a viewpoint that shows a large, dark house on the left with nothing to balance it, your painting will look wrong. The balancing shape does not have to be another house; it could be a suitably shaped shadow, a tree, clouds or even a small shape such as a figure, as long as it makes up for lack of size by being painted in a strong tone or colour.

Angle of viewing

Mikhail Zahranichny chose a relatively low viewpoint for his Gothic Quarter in Barcelona. This angle emphasises the height of the buildings and helps to recreate the confinement of the city's alleyways. Mikhail has strengthened the composition by balancing the illuminated buildings on the left with deep shadows and dark tones on the right.

High viewpoint

► The elevated viewpoint taken for *The Severn* Valley from Malvern has enabled Stephen Crowther to make the most of the foreground yard and the roofs, which would otherwise have been hidden. It has also provided a great expanse of landscape in the background, sweeping away to the distant strip of sky.

Pattern and decoration

Painting buildings from directly in front has a tendency to make them look flat, but in Ca d'Oro, Venice by Richard Beer the viewpoint has been well chosen, since the artist wanted to emphasize their decorative facades rather than the structures. The expanse of water, occupying over half the picture area, provides a counterfoil for the lovely intricate arches and balconies.

Buildings Composition

Because architectural subjects are among the more difficult, there is a tendency to forget about the purely pictorial values in the effort to get the proportion and perspective right. But composition is important whatever you are painting, so if you are working on location take a critical look at what is in front of you and think about how you can place the various elements to the best advantage.

To some extent your composition will have already been determined by the place you have chosen to paint from, but it is highly likely that you will have to do some fine-tuning, and you will also need to decide how much of the subject to include.

A viewfinder is a great help here. Some artists like to take an empty picture frame out with them so that they can hold it up and explore various possibilities, but you can make your own viewfinder simply by cutting a window in a piece of card.

Placing the centre of interest

The obvious centre of interest in David Donaldson's Village Church, Provence is the church, with its striking geometric tower, but the artist has taken care to place it off-centre and to balance it with the contrasting round mass of the tree on the left. The extreme foreground has been painted loosely in order not to steal interest from the church, but the bold, linear treatment of the plants and grasses leads our eye towards it, as does the directional brushwork on the tree.

Light/dark contrasts

In Jeremy Galton's The Empty Street, Lacoste shadows have been skillfully used as a dominant force in the composition, with the dark walls in the foreground framing the sunlit street and cool blue landscape beyond. The picture relies on the contrast between light and dark shapes, which have been observed and painted with great care to create a lively but harmonious effect.

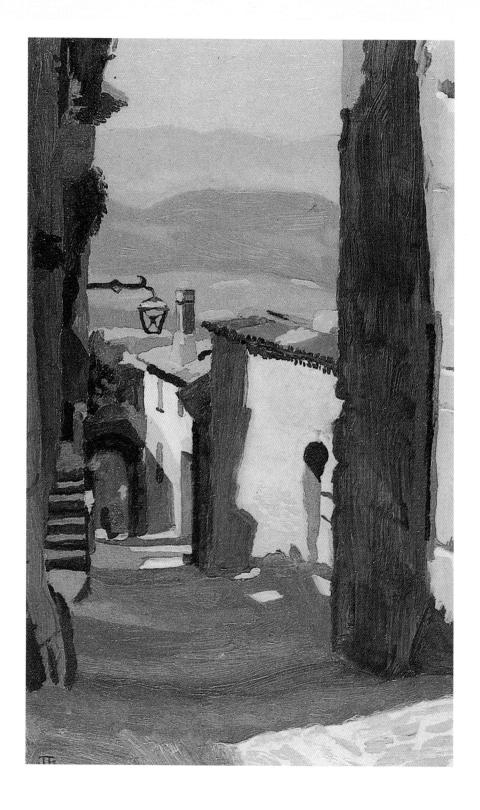

Buildings **Urban scenes**

City- or townscapes can be marvellous painting subjects, but they are somewhat daunting to novices for a number of reasons. One is the thought of coping with so much detail - brickwork, balconies, doors and windows, roofs and chimneys - in one painting. And another is the complexity of the perspective when buildings are set at angles to one another or on different levels. And, of course, there is the added problem of finding a suitable location in which to set up your easel, though you can, of course, work from photographs.

It is probably wise to avoid very ambitious projects at first, since it is easy to become discouraged. Choose a small section of the scene, such as the corner of a street, which has fairly simple perspective, and remember to ignore all details until the later stages, when you can see how many of them are really necessary to the painting.

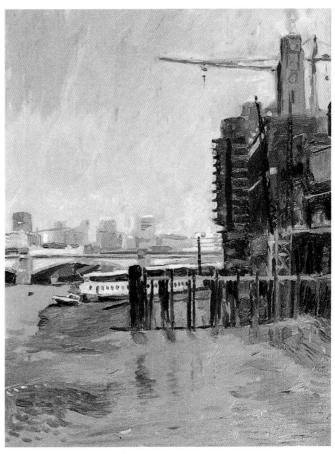

Working on location

Jeremy Galton's The Oxo Tower was painted on the spot. Before painting, the exact shape of the bridge and the piers of the jetty were measured and drawn in pencil, since mistakes would lead to an unconvincing portrayal of their construction. The main shapes were then rapidly outlined in thinned paint, and the mud bank and right-hand buildings blocked in with umbers and ochres. Thicker paint was used to add details in the later stages.

Non-realistic colour

Peter Graham's flamboyant style has transformed an ordinary corner of Parisian life into an exciting and colourful composition. As in all his paintings, he has used a heightened palette for Rue Saint-André des Arts, rejecting the browns and greys usually associated with urban subjects.

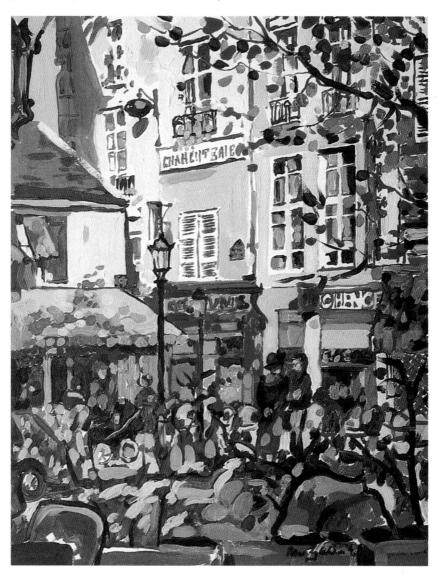

Buildings Interiors

Painting interiors involves a mixture of different artistic disciplines. Because there are elements of both architecture and still life, you will have to cope with the problems of perspective as well as with complex lighting conditions.

The rules of perspective are exactly the same for interiors as for exteriors. The parallel tops and bottoms of walls recede towards the same vanishing point, as do floorboards, the sides of tables and so on. It is wise to begin with one part of a room, and try to remain in exactly the same position when you make your preliminary drawing.

Exploring lighting effects is one of the most exciting aspects of painting interiors. Bright sunlight streaming through a window can illuminate one area, leaving strongly contrasting shadows, and window bars may cast regular or distorted patterns across the floor. It can be an interesting exercise to paint the same room at different times of the day to see how the variations in lighting affect the composition and colour key.

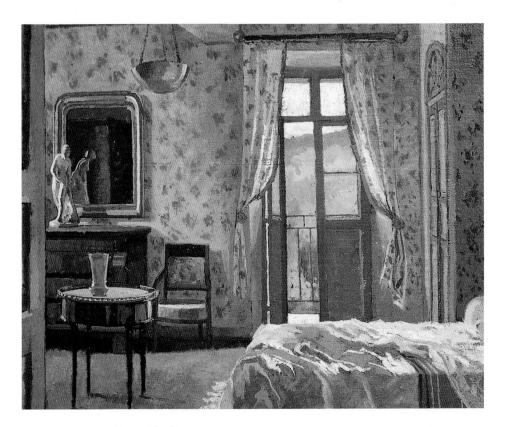

Interior light

For Interior at Les Planes James Horton has chosen a time of day when light enters the room not only through the balcony doors but also from an unseen window on the left of the picture. The high-key colour scheme enhances the feeling of light and airiness.

Suggesting space

In Richard Beer's Restaurant des Beaux Arts, Paris, the complex pattern of panels and arches makes a decorative composition, and contrasting bare floor space emphasizes the spaciousness of the room.

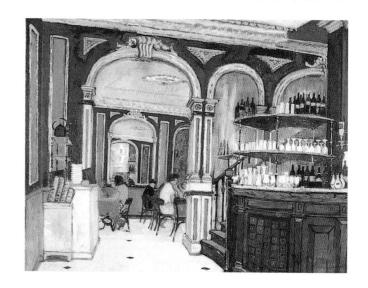

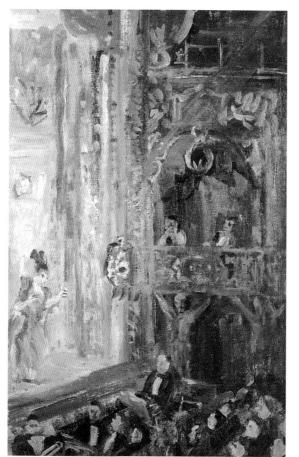

Artificial light

The warm glow of artificial light from the stage illuminates this small portion of the theatre, and Rupert Shepherd has made the most of this effect in Max Miller at the Music Hall. Theatres have always been a popular subject for artists, but it is, of course, usually necessary to work from small onthe-spot sketches.

People Achieving a likeness

The general shapes of faces vary much more widely than most people realize. You do not have to go right up to people to identify them; even at a distance a face can be distinguished as that of a specific person. It follows then that the first thing to do in a portrait is to establish the shape of the face and the underlying structure: the planes of the forehead and temples and of the bridge and sides of the nose, the positions of the eye sockets, cheekbones and chin.

The next step is to take careful measurements to establish these planes and their relationship to one another on canvas. Details, such as eyebrows and the precise line of lips, should always be built up slowly; if you begin with these you are less likely to produce a good portrait. You may even find that you can stop working on the picture far sooner than you had originally envisaged and with fewer details than you would have thought necessary.

Edge qualities

Rupert Shephard's formal portrait Professor Michael Shepherd has been built up gradually in layers over an underpainting (see page 112). The face has been described in considerable detail, but there are very few hard edges, the only relatively sharp contours being those of the nostril and the lips.

Body language

▼ In Susan Wilson's My Father the sitter's pose contributes as much to the likeness as the face itself. Always try to recognize particular ways of sitting and standing before you embark on a portrait, since these vary widely and can be very expressive.

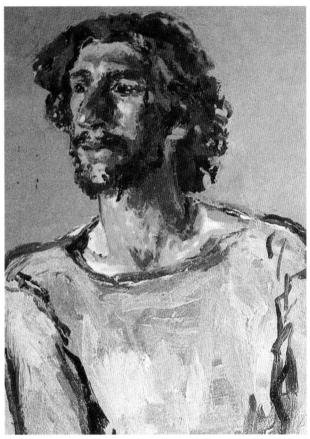

Expressive brushwork

▲ Susan Wilson's powerful portrait Farrell Cleary, with its loose, bold brushwork, makes an interesting contrast with Rupert Shephard's opposite. The posture and face are beautifully observed, and the composition is given additional strength by the firm black lines against the flat, neutral background.

People Composing a portrait

A portrait is first and foremost a painting and should be treated with as much regard for composition as any other subject. Decisions must be made about the position of the head, the clothing, how much of the person's body to show (you could stop at the shoulders or continue down to the hands), the background and any other objects you may want to include.

Study your sitter to analyse their most distinctive qualities. Most people have characteristic ways of holding their heads and hands and tend to sit in particular positions. They cannot assume these to order, but will gradually fall into them if allowed to relax and become used to being the object of close attention.

Choose a colour scheme for the picture but remember that it is usually best to keep the clothing and background fairly muted so that they do not compete with the face, which is always the focal point in a portrait. Experiment with the lighting, making sure that the shadows are cast in a way that defines the form of the features. In general it is best to avoid very harsh lighting as this can make the sitter look gaunt and old, and also robs the shadows of subtle nuances.

Complex compositions

In Adrian, what at first appears to be a fairly straightforward portrait of a young man in contemporary dress actually reveals itself to be a sophisticated example of the traditional 'painting within a painting'. The interior of the room is reflected behind the figure, with the artist, Jason Line, in the act of painting, and beyond this scene is depicted the nocturnal skyline of a large city. It is the careful judgment of value ranges for the three depths of the picture that maintains order within what could be seen as a modern classicist composition.

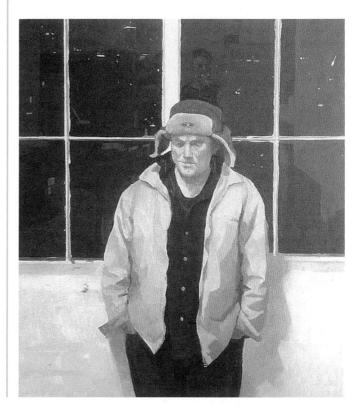

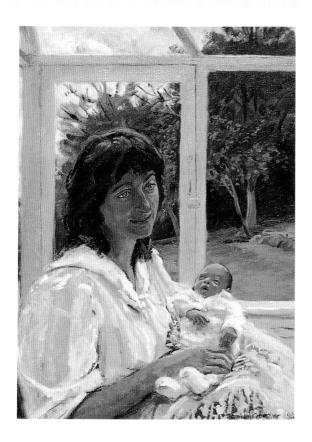

Painting a theme

In Stephen Crowther's The New Baby the theme of new life is stressed by the green foliage in the garden beyond, and the pose, with the tilting head. The hand resting on the baby's body expresses quiet devotion and pride in motherhood. The window bars provide an effective background frame for the delicate treatment of the sitter's head.

Head-and-shoulders portraits

Olwen Tarrant's Sydney from Stepney is a simple, classic head-andshoulders composition that focuses all attention on the head. The sitter's character and sombre mood is suggested by the very limited colour range in shades of brown.

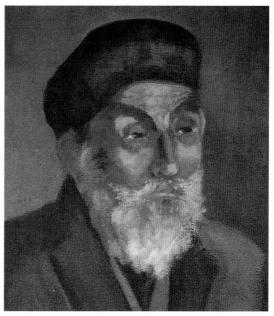

People The figure in context

In a portrait, or a picture that is primarily a portrait, the surroundings must complement the figure without competing with or detracting from it. However, even if they are treated in less detail than the figure, they need just as much thought. A setting can back up the portrait by offering a visual description of the interest or occupation of the sitter. For example, you might paint a child reading or drawing, or an artist standing at his easel.

Sometimes a figure painting is not so much an individual portrait as a portrayal of a person performing a particular task, in which case it is the action itself that must be conveyed, so look for the positions and attitudes that best suggest movement. Or a figure may be no more than one element in a landscape or interior. While relatively unimportant in itself, it can act as a focal point or provide a standard for scale. A tiny figure in the foreground of a mountain landscape, for instance, can emphasize the feeling of space and grandeur.

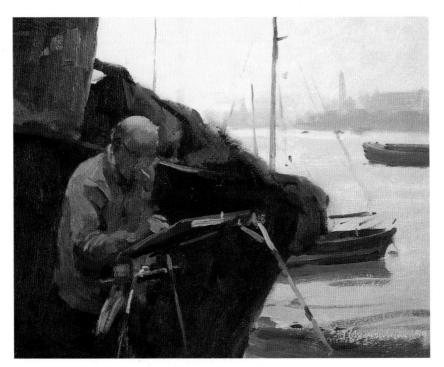

Characteristic activities

A favourite subject for the painter is a fellow artist engaged in the same activity, as in Trevor Chamberlain's *Working on Site, Bugsby's Reach.* The 'model' is likely to remain more or less immobile as long as you are there and can be shown in a setting that is wholly compatible with his or her occupation.

Figures in interiors

David Curtis's Study of Sian is both a fine portrait, in which the surroundings say something about the sitter, and a painting of a specific interior with the figure as the main subject. The composition is carefully planned: the cupboard doors at bottom right balance the window, and the diagonal of the chair back links the foreground and background.

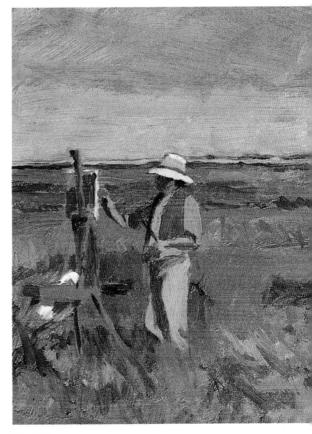

Telling a story

Jeremy Galton's small oil sketch James Horton at Work again shows a fellow artist at work. The painting has a slight narrative element - we feel that the artist may be working against time to complete the picture before the rain begins.

Tom Coates enjoys painting portraits of people he knows, but seldom accepts commissions, since he prefers retaining the freedom to explore new subjects and media. Besides oil paint, he also works in watercolour and pastel. He describes himself as a tonal painter, who perceives the subtle harmonies of colours, but has never been able to exploit brilliant hues. This preoccupation with light and dark is very apparent in this portrait, which is extremely tightly organized in terms of tone.

1 Working with heavily diluted paint, the artist establishes the overall composition and pose with broad strokes. The thickness of the lines avoids any precise definition of outlines at this stage.

2 He then begins to indicate the main planes of the face, delineating the cheekbone with a slash of colour.

3 Working on all the areas of the picture together, the important relationships of colour and tone

are mapped out. The brushwork is loose and free, and there is no attempt at detail at this stage.

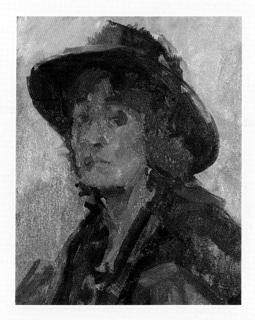

4 A few deft brushstrokes of cool and warm pinks, browns and yellows, and an individual face begins to emerge. Notice that the paint, thin in the early stages, is now quite juicy, in accordance with the principle of working fat over lean (see page 60).

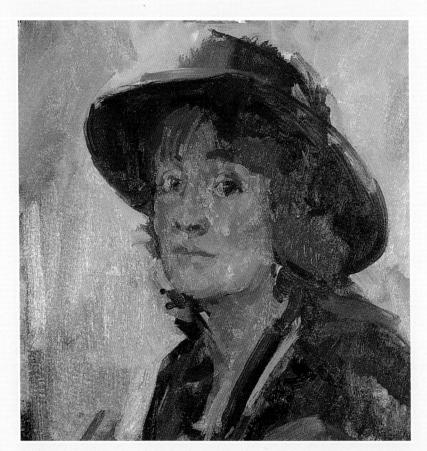

5 The steady build-up of paint gives form to the features and shape of the face. The artist now turns his attention to the background. Having tried out various combinations of pale and darker grey, he finally decided on a warm, mid-toned, greenish grey.

6 A little blending has smoothed out the contours of the face, and final touches such as the feather in the hat, the highlight on the earring and the stripes on the scarf have been added to impart a lively sparkle to the picture. The clothing, especially the area at bottom right, has been left vague so that it does not draw attention away from the face.

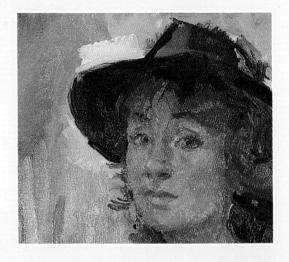

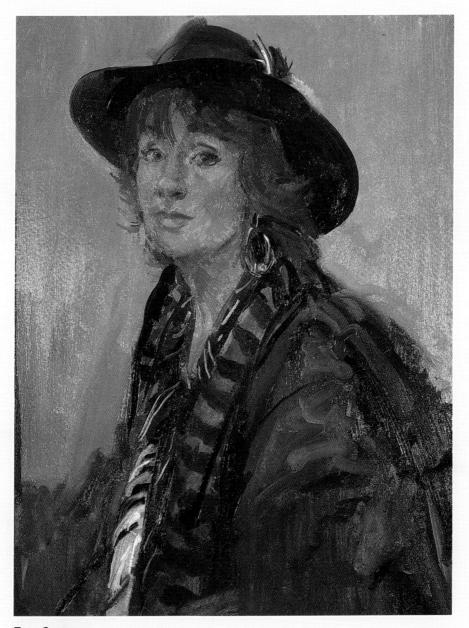

Tom Coates

Woman in a Black Hat

This is a wonderfully evocative study, capturing the sitter's relaxed pose and dreamy gaze. Notice how skillfully the artist has used the wet-in-wet technique (see page 82) to blend the colours, most noticeably on the shoulder and sleeve of the garment.

Still life Arranging the group

A still life should usually have some sort of theme running through it. The culinary theme, of fruit, vegetables and kitchen equipment is a favourite one, and because the objects are related through association, they form the basis of a naturally harmonious picture. Another type of theme is the biographical or narrative one, in which personal belongings such as shoes or a chair are depicted – Van Gogh painted both at different stages of his career.

A theme can also be purely visual, with objects chosen specifically for their shapes or colours. Plates and bowls on a table, for example, provide an arrangement of circles and horizontals (or diagonals) while bottles comprise a series of uprights and curves. A colour theme could take the form of predominantly blue, white or yellow objects.

Arranging a collection of objects so that they make a pleasing composition is one of the hardest aspects of still-life painting, so be prepared to take time at this stage. You might begin by depositing the objects at random, perhaps even without looking. Then look at them through a viewing frame and adjust them until you begin to see a satisfactory composition that has both balance and a sense of movement.

Compositional structure

Successful arrangements are often based on a simple geometric pattern. In Anne Spalding's *The Mantelpiece* the objects and mantelpiece together form a rough cross shape. The dominant horizontals and verticals are balanced by the diagonal formed by the box placed at an angle.

A colour theme

The objects in Jeremy Galton's Still Life in Pink and Blue were chosen primarily for their colours, as the artist wanted to experiment with a specific colour scheme. A good deal of arranging and rearranging was done until the arrangement looked right, and other objects originally included were removed.

Lighting

Lighting plays a very important part in still-life painting. In James Horton's Pottery and Glass a fairly strong light from the right casts a dark shadow behind the objects and progressively deepens the ones around them to the left, giving form and solidity.

The casual look

A Chair and Copper Pot is the kind of still life that you might almost happen on by accident (see Found Groups, page 178). But in fact Jeremy Galton arranged the chair and pot with care before moving the set-up nearer to a window to provide a better light.

Still life Found groups

Still lifes are usually (though not always) intended to look natural. but most are in fact very carefully arranged in advance. The essence of 'found' still life, however, is that it is genuinely not arranged. Sometimes you will just happen to see something, whether inside or out, that has the makings of a painting. This could be virtually anything: pots and pans in a kitchen; some dishes and a loaf of bread left over from a meal; objects on a mantelpiece; a book on the arm of a chair; flowerpots or chairs in a garden, or even stones and pebbles on a beach.

Such objects may be distributed in a more interesting way than you could hope to achieve yourself. Some may have fallen over, others will be half hidden, and their sizes and colour distribution will be random. It is up to you to make the most of the subject by choosing the best vantage point from which to paint.

Using paint freely

The casual, found' look of Anne Spalding's *The Chest of Drawers* is enhanced by a slight untidiness and by a free, spontaneous-looking use of paint. The open drawer, the sloping books and the shoes on the floor suggest a fleeting moment before things are cleared up.

Seizing opportunities

Pictures like Anne Spalding's The Black Slippers are often inspired quite by accident – you suddenly see a potential picture among the visual clutter of your environment. It is often necessary to rearrange things slightly, or to remove a superfluous object, but otherwise your still life is ready to be painted.

Artful arrangement

It is surprisingly difficult to arrange objects randomly so that your still-life arrangement does not look contrived. John Monk's Spanish Archive, although obviously arranged – with the thin magazine protruding from the larger volume – nevertheless looks convincingly natural, and has been painted broadly and economically with controlled handling of impasto (see page 88).

Still life Floral groups

Flower pieces, whether living plants in a pot or cut blooms in a vase, continue to be a favourite still-life subject. They can be painted on their own or used as part of a mixed group, perhaps including fruit or an attractive bowl or glass.

Flowers are not easy to paint, and one of the commonest causes of failure is overworking the paint in an attempt to get in every tiny detail of petals, leaves and stems. It is essential to simplify to some extent, and to do this you need to be aware of the main characteristics of the flowers. Are they fragile or robust; rounded or trumpet-shaped; are there several flower-heads on each stem or just one? How thick is the stem in relation to the flower-heads? So before starting to paint, take a good look and make sure you understand the structures.

Another thing that goes wrong with beginners' flower paintings is that the stems are not properly related to their container, so if your arrangement is in an opaque vase try to imagine the stems below the lip of the vase so that you can get the direction and proportion of those above it right.

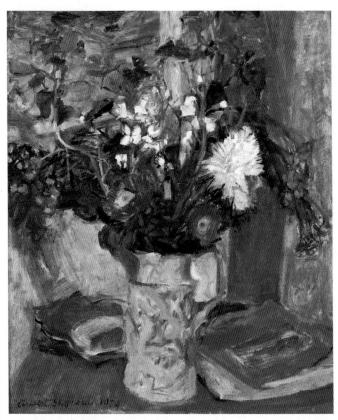

Filling the space

Because a jug or vase is a tall, thin shape, you often need to bring in other objects beside it so that you don't have an area of blank space. In Rupert Shephard's Mixed Flowers in a Jug the books provided a balance for the jug as well as allowing the artist to introduce more colours.

Stressing the pattern element

In Mary Gallagher's bold and colourful painting Still Life: Red Tulips the all-over pattern formed by the group of objects and flowers is more important than the representation of three-dimensional form. The flowers especially are treated largely in terms of flat pattern, emphasized by the thick, dark outlines around the shapes.

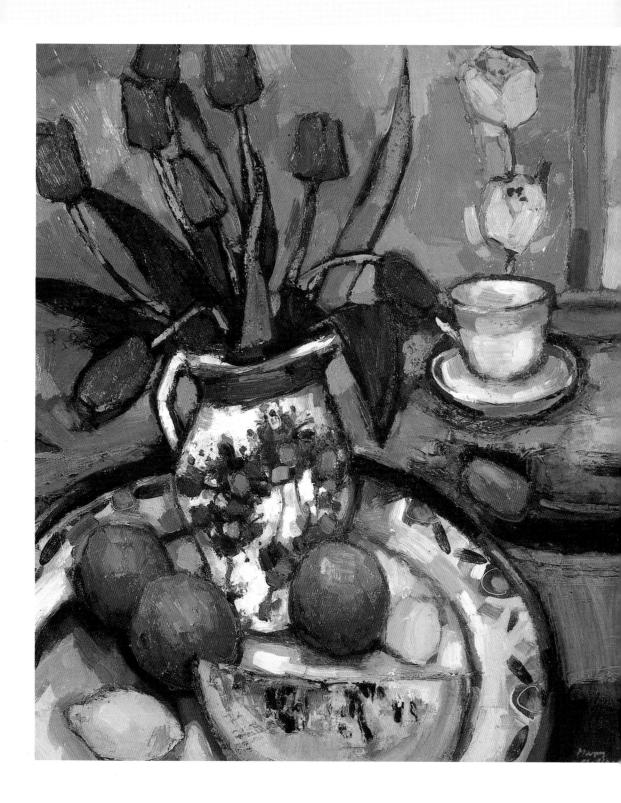

Tutorial White flowers

This is a relatively small painting done on primed board and completed in one session, as are most of Jeremy Galton's still lifes and landscapes. He usually paints 'sight size' - that is, so that the edges of the subject coincide with those of the board. This makes it easier to take measurements with the brush handle held up at arm's length, and these are transferred directly to the picture surface.

> **1** Although the arrangement is a simple one, it was given careful consideration before the painting began. The plant was placed on the tablecloth and rotated until it provided the most interesting configuration of flowers.

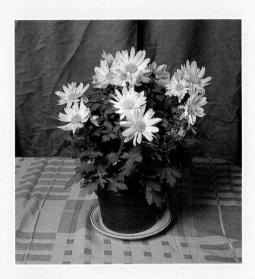

2 The board has been toned with diluted yellow ochre, since the artist dislikes painting on white surface. He begins with a careful drawing, noting the position of the flowers in relation to each other.

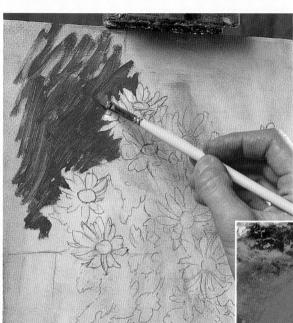

3 Because the flowers are basically white, he has chosen to block in the dark background first. His left hand resting on the easel acts as a support for his working hand.

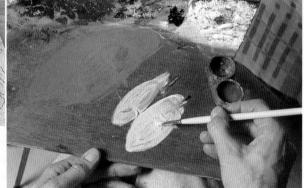

4 The colours for the petals are mixed carefully so that no streaks remain in the paint. The mixture shown here consists of white with a little alizarin crimson and yellow ochre.

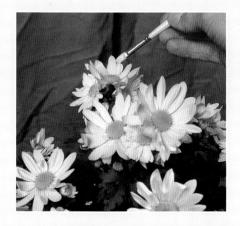

5 To make sure that the colour is correct, he holds the brush up close to the petals and adjusts the mixture until he is satisfied with the match. This is a useful way of identifying colours and tones, which can be unexpected and surprising.

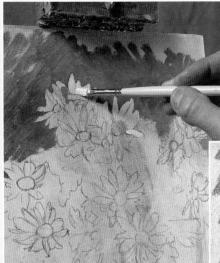

6 The first mixed colour is now applied. Since few petals are exactly the same colour, repeated alterations of the paint mixture are required as work progresses.

7 Before completing the petals, some of the foliage, especially the darkest areas, are painted. Throughout the painting, the colours are mixed with a little medium consisting of one-third linseed oil and two-thirds turpentine.

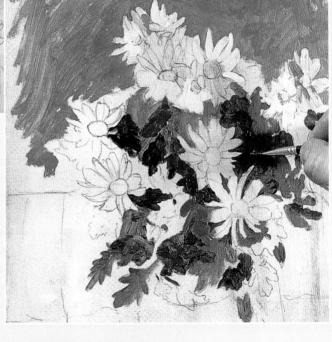

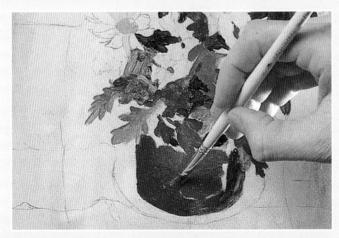

8 The yellow flower centres and the pot provide warm colours in a predominantly cool picture.

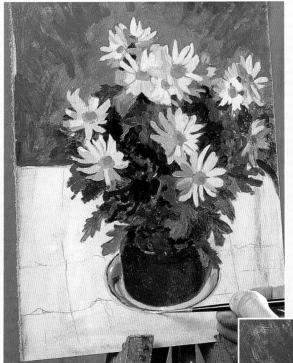

9 The artist wants to make sure that the saucer retains its crisp edge, so he paints this before the larger area of the tablecloth, using a pointed sable brush.

10 With the tablecloth now complete, the shapes of the most important leaves – those that stand out against the background - are defined with a sable brush.

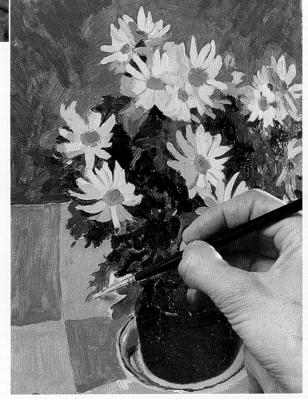

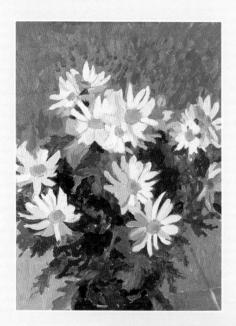

11 This detail shows that the 'white' petals range in colour from yellowish whites through pinks to fairly dark purplish greys. Many of these colour variations are caused by the angles at which the petals lie to the light source.

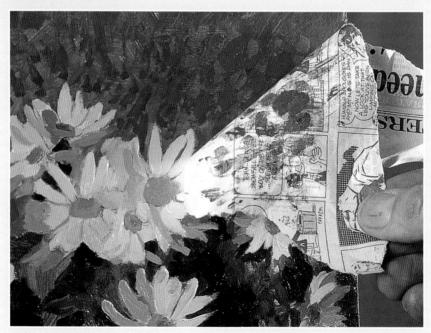

12 The little patches of blues and ochres in the background provide additional interest but were initially too clear-cut and bright, so the tonking method (see page 102) is used to remove some of the paint.

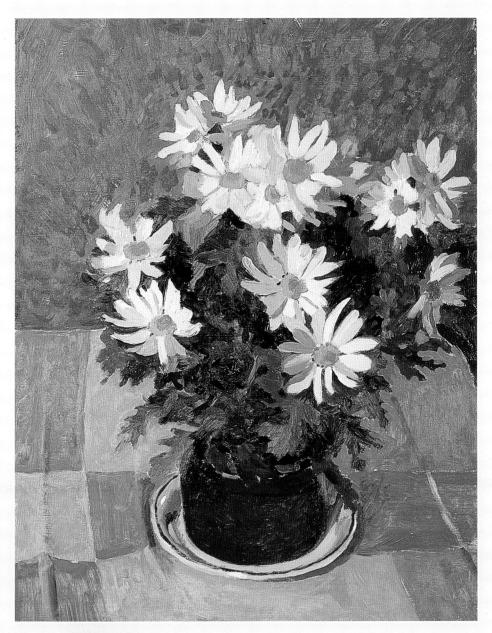

Jeremy Galton

White Chrysanthemums

In the finished painting, the whites stand out bright and clear due to the careful handling of the tones and colours in the shadowed area. It is often hard to appreciate how dark white objects can be where they turn away from the light.

Index

round 12,70

sable 12, 63, 70, 122, 185 synthetic 70, 122

Α brushmarks, varied 12,71 colour(s): accents 34, 140, 156 accents 34, 89, 94, 140, 156 brushwork 70-71, 142 to balance 138 acrylics: brushes for 12 broken effects 96 descriptive 71, 73, 142, for ground colour 24 144, 168 to butt up 76 for underpainting 101, 112, directional 144 complementary 29, 124, 126, 150 120 expressive 73, 167 additives for texturing loose 71,81 to darken 124 110-111 in printing 119 to enliven dull 126 to use 72-73 after-image 150 gradations 65, 96, 127 alkyd medium 23, 42, 57, building up a painting 66-67 around 24-25, 106 77,135 buildings: composition 158, intensity 29 alla prima painting 62-63 160 to keep clean 125 architectural subjects see viewpoint 158-159 to knock back 126 buildings; urban scenes see also interiors; urban to match 138, 183 artists' colours 10,34 scenes to mix 28-29, 36, 125 see also individual colours C В neutral 29, 50-51 backgrounds 108, 112, 148, calico 18 non-realistic 163 158, 168, 174, 183, 186 canvas 16, 18 opacity of 30 blacks, coloured 124 to avoid pressure lines 129 primary 28, 29 to carry wet 134 secondary 28, 29 blending 64-65, 78, 96, 127, 174 to remove dents in 129 of shadows 150 edges 76-77 to re-use 129 strength of 30 rough 127 to roll 128 tertiary 29, 40, 48 blot-off 115 to size 20 transparent 30, 56-57 board, painting 16 to stretch 20-21 unmixed 34-35 underdrawing on 68 to prepare 17 warm and cool 31, 32, 140, body language 167 cardboard 16 141, 156 browns: to mix 40-41 Cezanne, Paul 12 colour wheel 28 to use 42-43 charcoal 46,68 composition: balance in 158, brushes 12, 122 cityscapes see urban scenes bristle 12, 70, 100, 122, 127 clouds 146-147, 154 in buildings 158, 160 to clean 122 scumbled 100 in landscapes 147, 150 fan 74, 127 cold, to suggest 140 in portraits 164, 171 filbert 12,70 collage 83 in still life 176 flat 12,70 to unify 80 hog 100 Constable, John 62

D

Degas, Edgar 16
detail: to add 12, 148, 155
architectural 155, 162
in portraits 66, 83, 166
to redefine 120
drawing into paint: in
monoprinting 118, 119
with pencil 78, 120
dry brush technique 74–75, 120
drying mediums 22, 23, 135
drying time 60
to speed up 88, 135
dullness, to enliven 126

Ε

easel, to stabilize 133 edges: broken 76 to create hard 78–79 crisp 185 hard and soft 76–77 in portraits 166 to redefine 120 extenders 88

F

fat over lean 60–61, 173 figure painting 96, 170–171 finger painting 96–97 flax 18 flower painting 180–181 tutorial 182–187 focal point 38, 139, 145, 156 in portraits 168, 170 foliage 71, 148, 184 foregrounds 75, 138, 139, 142, 145, 158, 160, 170 'found' still life 178–179

G

gesso 17 glazing 22, 56–57, 83, 86–87, 126, 144 gouache underpainting 120 greys: to mix 48–49 to use 50–51 greens 138–139, 149 to mix 36–37 to use 38–39 ground: coloured 80–81 to tone 24–25 unpainted 80–81, 152, 153,

Н

hessian 18 highlights 47,61,63,77,78,80, 83,156,174 flicked 14 in greens 138 impasto 60 on skin 52–53,54

ı

impasto 22, 60, 88–91, 179 medium 88, 92, 111, 115 Impressionists 62, 70 imprinting 114–115 interiors 164–165, 171

K

knife painting 14, 78, 92–95, 138 knives: painting 14–15, 88, 92, 104 palette 14–15

L

landscape: summer 138–139 tutorial 152-157 winter 140-141 see also skies; trees; urban scenes; water layers 56-57, 60-61, 62, 67, 88, 96, 98, 104, 106 see also dry brush; glazing; wet-in-wet; wet-on-dry Leonardo da Vinci 64 light over dark 75, 100 lighting: in interiors 164, 177 in portraits 168 on skin 52 in still lifes 177 linen 18 linseed oil 22, 23, 50, 84, 88, 127 Liquin see alkyd medium location, working on 10,73, 132-135, 152, 154, 160, 162

drying 22, 23, 135 78, 120 sgraffito 106–109, 114 glazing 57, 86 for short-term subjects 132 shadows: to glaze 86, 87 impasto 88, 92, 111, 115 for underdrawing 62, 68 in greens 138 to mix 22 perspective: complex 162 in interiors 164 misty effects 96, 104–105, 140 through brushwork 142 160 mixed media 118, 120–121 photographs, to use 146, 162 in portraits 168 Monet, Claude 70 plaster as additive110 in still lifes 177 monoprinting 118–119 plein air painting 62 short-term subjects 132 multiple printing 119 pointillism 125 simplification 142, 148, 180 multiple printing 119 pointillism 125 skin tones 52–53 multiple printing 98, 99 context 170–171 space, to suggest 76, 139, 165 see also pointillism drawing in 68–69 spattering 117 oranges: to mix 28,44 edges in 166 sponge painting 98–99 to use 46–47 tutorial 172–175 stali, to apply 24 overpainting see glazing primer/priming 16, 17, 20, 129 lighting 177 painting out of doors 62 see also location, wor
--

supports see surfaces	V
surfaces 16–17	Van Gogh, Vincent 176
care of 128–129	vanishing point 164
fabric 18–19	varnish/varnishing 22, 23, 127,
to re-use 129	132
white 80	viewfinder 160, 176
see also canvas; ground	viewpoint 158–159
T	W
texture(s): additives 110–111	water: moving 142, 144–145
broken 120	still 97, 142–143
to describe 70	watercolour underpainting 120
painted 88, 94, 98, 114–115,	wedges 21, 128
138	wet-in-wet technique 63,78,
printed 118, 119	82, 90, 144, 153, 154, 175
scumbled 100, 101	wet-on-dry technique 83
of sponges 98	Whistler, James 104
to suggest 74	white(s) 186, 187
of surface 16, 17, 20, 100	effect of adding 31
thinner/thinning 10, 22-23,	white spirit 22, 122
112	to re-use 123
Titian 70	winter landscapes 140–141
tone, to darken 124	wood shavings as additive
tonking 83, 102-103, 186	110, 111
townscapes see urban scenes	
trees 148-149	
Turner, JMW 86	
turpentine 22, 23, 50, 60, 112	
tutorials: flower painting	
182–187	
landscape 152–157	
portrait 172–175	
U	
underdrawing 46,62	

in portraits 68–69 underpainting 66, 83, 86, 100, 112–113, 120, 148 urban scenes 162–163

Credits

While every effort has been made to credit contributors, Quarto would like to apologize should there have been any omissions or errors – and would be pleased to make the appropriate correction for future editions of the book.

All other illustrations and photographs are the copyright of Quarto Publishing plc.